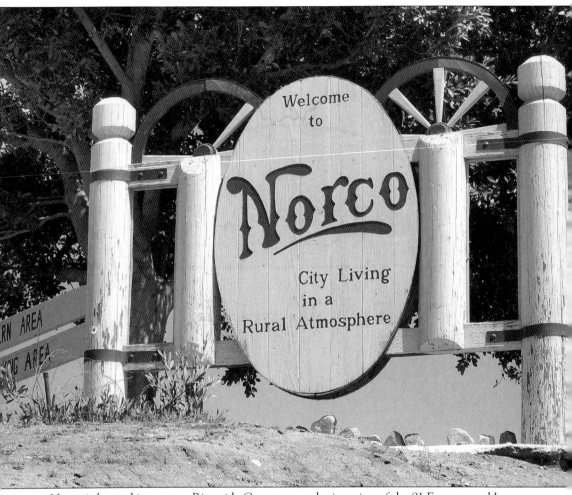

Norco is located in western Riverside County near the junction of the 91 Freeway and Interstate 15, about 50 miles southeast of Los Angeles.

Marge Bitetti

Copyright © 2005 by Marge Bitetti
ISBN 0-7385-3035-2

Published by Arcadia Publishing
Charleston SC, Chicago IL, Portsmouth NH, San Francisco CA

Printed in Great Britain

Library of Congress Catalog Card Number: 2005929114

For all general information contact Arcadia Publishing at:
Telephone 843-853-2070
Fax 843-853-0044
E-mail sales@arcadiapublishing.com
For customer service and orders:
Toll-Free 1-888-313-2665

Visit us on the internet at http://www.arcadiapublishing.com

Contents

Acknowledgments		6
Introduction		7
1.	The First Californians	9
2.	Agriculture	15
3.	Education	31
4.	Houses and Business	37
5.	Lake Norconian Resort	45
6.	The Navy	55
7.	Churches	77
8.	Mayors, Beauty Queens, and Rodeos	81
9.	Horses and Riders	95
10.	People and Places	109

Acknowledgments

In doing the research for this book, I learned that history tells powerful stories and helps us to understand the present. Learning about the real struggles and stories of the people of Norco taught me that there are many different lessons about courage, successes, and failures. There are many people that I wish to thank and acknowledge for their assistance and contributions to this book. First it is fitting to thank the men and women who shaped the past of Norco and the people who had the wisdom to move forward. Special thanks to Mayor Herb Higgins, city manager Jeff Allred, city clerk Deborah McNay, and the staff who provided time and assistance to make this project a reality. Thanks are extended to Ron Snow and the members of the Norco Historical Society. I wish to thank Roberta Spieler and the U.S. Navy for granting permission to use historic Navy photographs, a contribution that greatly helped to enrich this book. I wish to thank the Julian Historic Society for sharing stories and information about Norco's founder, Rex B. Clark, who also had a home in the city of Julian. I wish to thank Robert Laurence for sharing his photographs. I also want to thank so many people living in Norco who were willing to take the time to share stories with me about their city. I wish to thank my husband, Tony, and daughter Danielle for always saying "yes" when I needed help or moral support. I want to thank Arcadia for this wonderful experience and opportunity and finally to thank God for the talent and ability that he has given to me.

INTRODUCTION

Norco is an animal-keeping, equestrian-oriented community whose residents enjoy over 400 acres of parkland and 95 miles of horse trails. The city's mutual love for animals has created a close-knit community whose residents are active in the local schools, churches, and various civic groups. Norco encompasses about 14.5 square miles and is located adjacent to the Interstate 15 freeway in western Riverside County.

Norco plays host to several of the Inland Empire's most sophisticated high technology organizations. The Naval Surface Warfare Center Corona Division is responsible for assessing the reliability of naval weapons systems and the combat readiness of the fleet. It is supported by Computer Sciences Corporation, a defense contractor. Riverside Community College's western campus and the Center for Applied Competitive Technologies are also located in the city. Working with business leaders and partners from all walks of life, the citizens of Norco believe that a strong business climate and continued economic growth will create the financial fuel to fund essential government services as well as enhance a community rich in culture, recreation, and community activities.

Norco is engaged in a never-ending quest to enhance its animal-keeping lifestyle, as is evident in the city's 44-acre equestrian center at Ingalls Park, its state-of-the-art, Western-motif fire station on Sixth Street, and in the facade improvements on the buildings along Sixth Street and Hamner Avenue. Nowhere else will you see horse trails traversing from residential homes to businesses facilitated by crosswalks for equestrians and hitching posts for their steeds.

Thank you for taking this opportunity to become better acquainted with Norco. We hope to welcome you first as a visitor and then as a business partner and neighbor.

—Jeff Allred, City Manager
City of Norco

Author Marge Bitetti, a novice equestrian rider, saddles up for a ride on a rented pony. The author was born in Los Angeles and has been a published writer since 1982. In addition to writing city histories, she recently completed a black comedy as well as a historic play about the first woman pilot in America, Bessica Raiche. Bitetti assists nonprofit organizations with marketing and grants. She is a graduate of Cal State University Long Beach with a bachelor's degree in radio, television, and film and a master's degree from Webster University in Business Management.

One
THE FIRST CALIFORNIANS

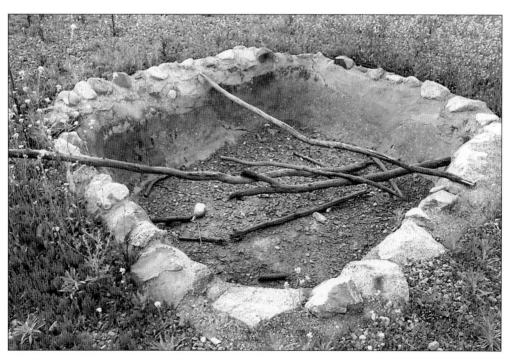

The history of the Luiseno people in the general area surrounding Norco dates back more than 10,000 years. The Spaniards associated the native people with the Mission San Luis Rey in North San Diego County as Sanluisenos. In 1850, after California became a state, the Luisenos were unable to show clear title to the land so they were evicted and relocated. The Luisenos used tanning vats for making leather from cowhides. The vats in this photograph were restored by the Billy Holcomb Chapter of E. Clampus Vitus in 1981.

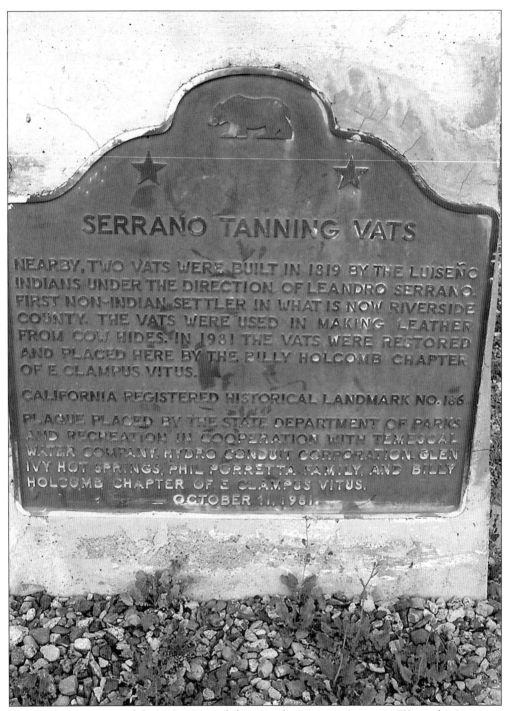

Leandro Serrano was a solider in San Diego fighting in the Mexican-American War under Governor Portola. His duty in battle earned him a vast amount of land in the Temescal Valley—over 22,000 acres—that later became Norco. Serrano's marriage to Maria Presentacion Yorba joined two families who helped to build California. Serrano was the first non–Native American settler in Riverside County. These Serrano tanning vats comprise California State Historic Marker No. 186.

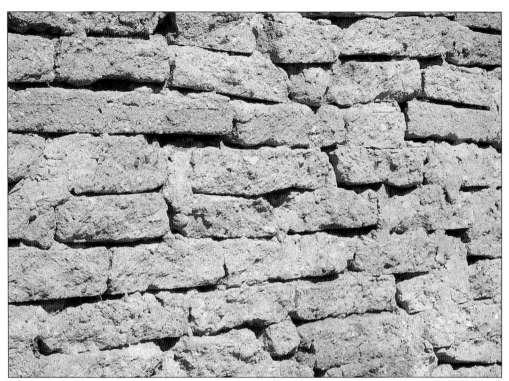

Adobe bricks were made by the Native Americans out a mixture of straw, mud, and water and left outside in the sun to dry. Adobe bricks were used to build the homes and other buildings on the large ranchos. The bricks in this photograph date to the rancho days of early Norco.

Dona Vicenta Sepulveda de Yorba de Carrillo was the widow of two well-known early Californians, Tomas Yorba and Ramon Carrillo. After their deaths, she inherited a large tract of land. She lived and raised her family on the rancho that stretched from the Eastvale area of Norco, north of the Santa Ana River near the border of what is now Norco, westward toward Chino near the present location of the Prado Dam. In 1857, she owned roughly four leagues of land, which amount to 17,600 acres. In 1869, Vicenta moved to Anaheim and lived there until her death in 1907 at the age of 94.

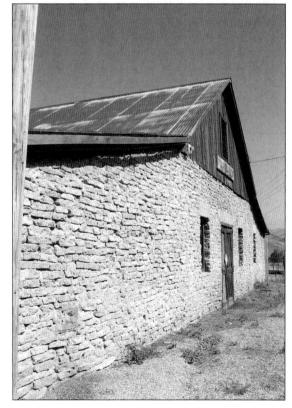

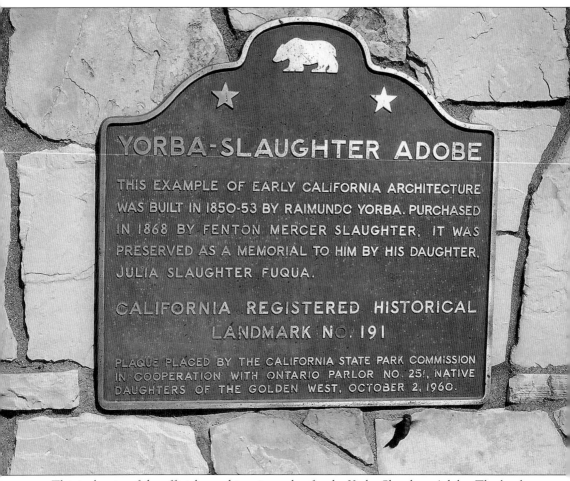

This is the site of the official state historic marker for the Yorba-Slaughter Adobe. The land was originally received from a Spanish land grant for service in the army of General Portola. The site was built in 1850–1853 by Raymundo Yorba, brother of Tomas Yorba and brother-in-law of Vicenta Carrillo.

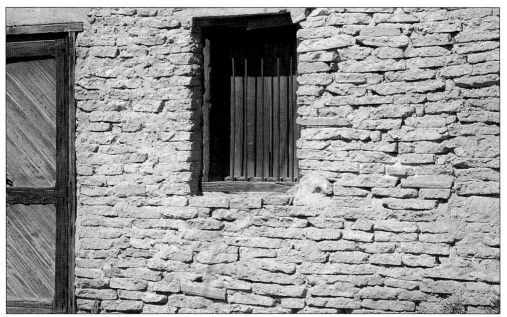

The Yorba Adobe, located on the banks of the Santa Ana River, was purchased in 1868 by Fenton Mercer Slaughter. It provides a fine example of early California architecture using adobe bricks.

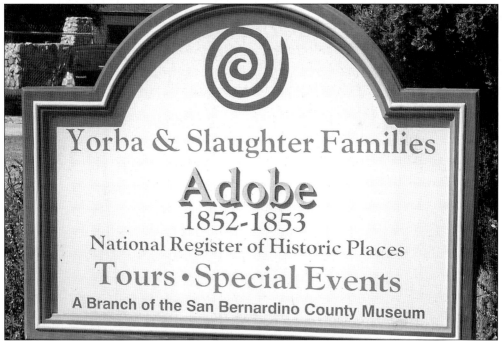

After the death of Jose Antonio, Yorba, his sons, and their families inherited the vast Yorba Rancho, which was located off the present-day Interstate 71 freeway area in Chino just across the Santa Ana River from Norco. In the days of the rancho, the land owned by Vicenta Sepulveda de Yorba stretched from what is Orange County today east to Riverside County. After her second marriage to Ramon Carrillo, her land holdings stretched into northern San Diego County. She had the skill to manage a large ranch and workers with herds of 500 animals or more.

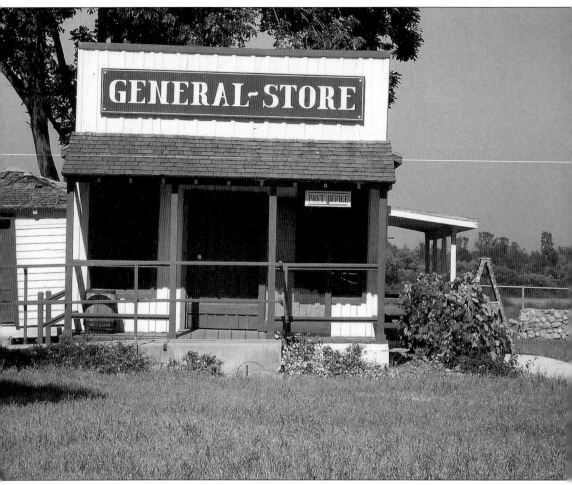

This store, located on the historic Yorba-Slaughter Rancho, is a typical example of the businesses that were found along the stagecoach stops. The Butterfield Stage line, which ran from Missouri to San Francisco from the 1850s through the early 1900s, helped to build many local towns. People moved to North Corona, which became Norco, as a result of improved transportation.

Two

AGRICULTURE

By the turn of the century, Riverside County was booming. The City of Corona in the west of the county earned national attention as the "Lemon Capital of the World." Just seven miles north of Corona was the area known as the North Corona Land Company. Over several decades, this 14-square-mile area had many names before it settled on Norco.

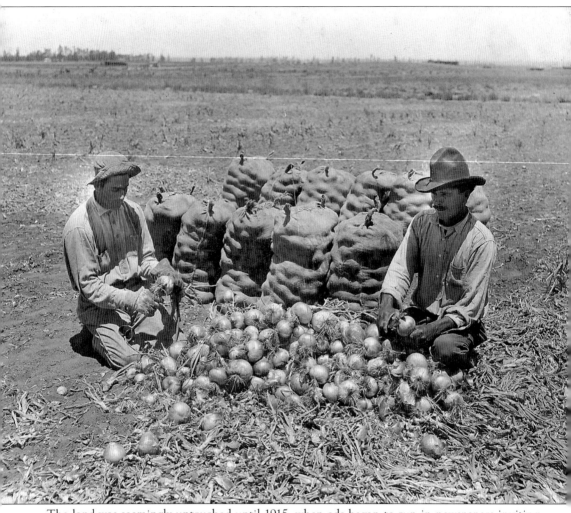

The land was seemingly untouched until 1915, when ads began to run in newspapers inviting people to purchase parcels of five acres or more at $275 an acre. Although the area was advertised as the ideal place to grow citrus crops, the high winds and warm temperatures in Norco soon proved that the area called the Citrus Belt Land had the wrong climate for growing citrus. By 1916, about 40 families had moved west and settled in this area. Here unidentified farm workers package onions in burlap sacks on a farm belonging to early Norco settler E. G. Barns.

John Thomas Hamner served on the Riverside County Board of Supervisors from 1903 to 1923. After moving to California as a young man he worked at a variety of jobs, eventually owning more than 1,000 acres in the Corona, Arlington area. Although he had a limited formal education, he had the ability to create his own fortune. He raised livestock, grew alfalfa, and became a walnut grower on over 200 acres in early Norco. He was also one of the first organizers of the First National Bank of Corona.

Hamner Avenue was originally known as the Corona-Eastvale Road. John Thomas Hamner had a major part in the construction of the road, which runs north and south through the center of Norco and serves to honor this industrious farming pioneer, who died in 1949 at the age of 87. The Tyler-Magnolia shopping center across from the Galleria at Tyler is still owned by the Hamner family.

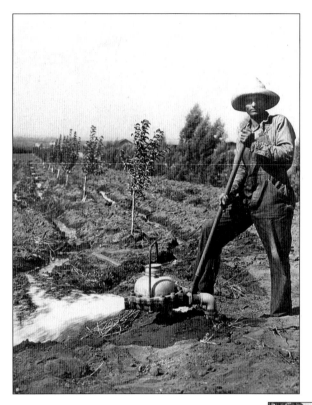

In 1920, the Corona Chamber of Commerce offered a prize of $10 to the best new name for Citrus Belt Land. The winning name was Orchard Heights. Although the area was not ideal for citrus, it became a successful agricultural farming community. Water was needed to nourish the dry sandy soil, and irrigation of the land was necessary to make the crops grow. An unidentified man irrigates the trees.

This unidentified woman is believed to be Mrs. O. R. Fuller, wife of a prominent landowner. At one time, the Fuller Ranch covered 5,000 acres in the northern section of Norco known as Eastvale. This area was bordered on the east by Hamner Avenue, on the north by Cloverdale, and by Archibald Avenue on the west. O. R. Fuller eventually became the founder of the City of Fullerton.

Orchard Heights, as Norco was called in the early 1920s, had many crops and orchards. Oranges, peach trees, apricots, alfalfa, vegetables, and fruits were planted and hogs and chickens were raised. Farms ranged in size from five to 500 acres. Apricots were abundant in 1920 and many tons were harvested for canning. This photograph from 1924 shows a field of lettuce ready for picking.

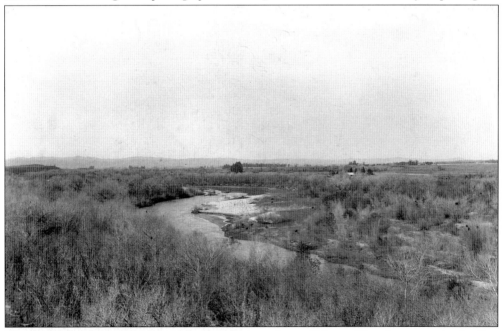

The Santa Ana River serves as the northern boundary of Norco. The river starts in the San Bernardino Mountains in the north and flows west nearly 100 miles until it reaches the Pacific Ocean. The Santa Ana River has overflowed several times since people began putting down roots in the area. Memorable flooding occurred in 1825, 1862, 1916, 1938, 1983, 1995, and 2005, causing loss of property and lives.

Norco in the early 1920s had wide-open spaces with ample land for cattle, horses, and crops. This is a view from the center of Norco looking northwest. A flowing range of low, rolling hills defines the east side of Norco.

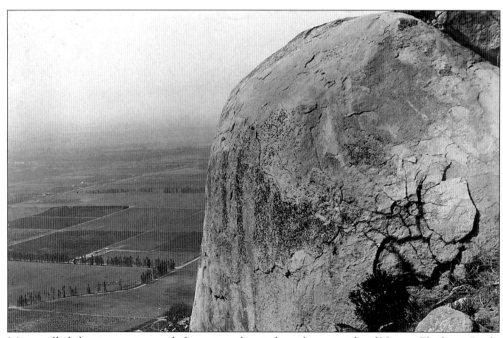

Many called this interesting rock formation, located on the east side of Norco, Elephant Rock. Local horseback riders also know it as Rattlesnake Hill for the abundance of rattlesnakes. Extreme caution is needed when riding and hiking in this area.

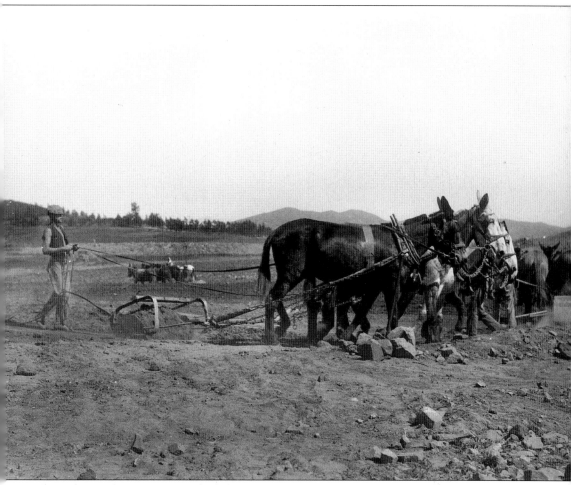

An unidentified man plows a rocky field with a team of mules. Early Norco pioneers were attracted to the large lots that were available for homesteading. Getting the land ready for planting was very hard work because the land was dry, sandy, and rocky. The early settlers' hard work and determination helped to develop the community.

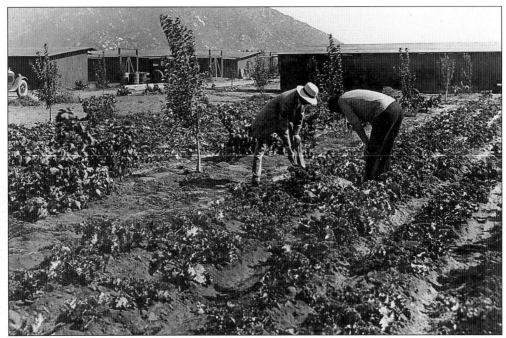

Although not suitable for citrus, Norco developed as an agricultural community because the land was ideal for other crops and for farm animals. Walter and Cordelia Knott, founders of Knott's Berry Farm in Buena Park, moved to Norco from Pomona. Here unidentified men look after a crop. Many of the local farmers dug their own wells to supply sufficient water for their farms.

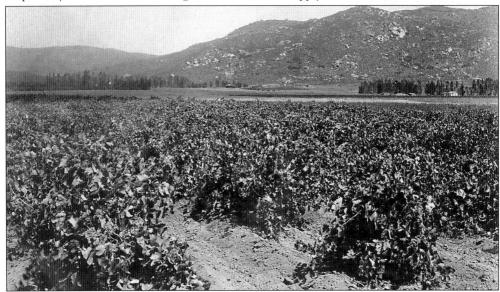

Walter Knott planted 10 acres of blackberries near Hillside Avenue and Third Street. In 1920, after struggling with insufficient water for nearly three years, Knott and his wife moved to Buena Park and leased 20 acres. Here he planted his berries and Cordelia Knott began making berry pies and chicken dinners. The couple's hard work eventually led to the development of the well-known theme park Knott's Berry Farm. Unrelated to the Knott's farm is this vineyard, growing on thirsty soil.

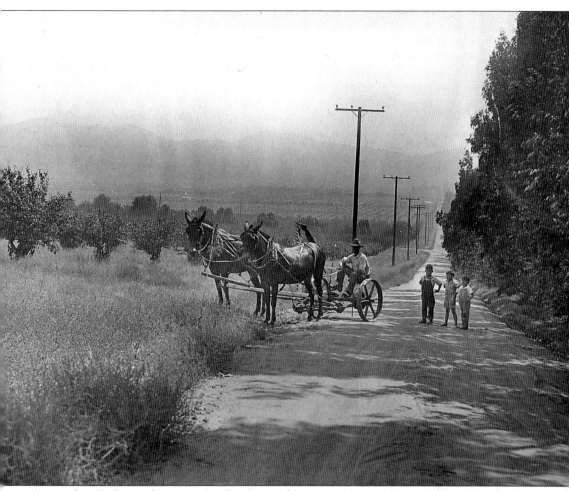

An unidentified man drives a pair of mules on this quiet Norco road in 1924. Peach orchards line one side of the road and eucalyptus provide shade for the three small children who stand watching on the other side. Telephone poles also line the road. Telephone service began in the general Corona-Norco area in 1899.

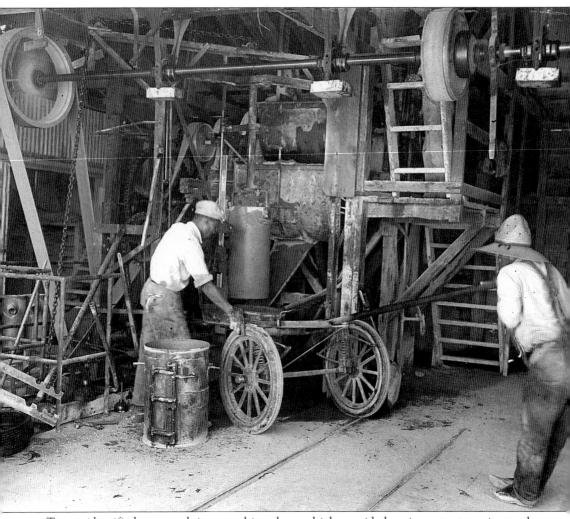
Two unidentified men work in a machine shop, which provided an important service to the community because farmers were able to have their agricultural equipment repaired.

Mr. Zeifuss was an early settler in Norco. His hard work and determination enabled him to earn a living off the land. Many families' roots are deep into Norco, and generation after generation are proud to call this unique rural town their home. It is typical to find people in Norco who have been in the community since the 1960s when the city was incorporated.

This unidentified man hoes crops as a small boy watches. Early settlers taught their children the benefits of hard work. During the early 1900s, small farms grew rapidly in the North Corona area, later known as Norco. Farmers had to spend long hours in the hot sun doing strenuous work.

A Norco resident, Mr. Crary is pictured with his extremely large bunny. Many of the farm owners took pride in their animals and groomed them for local shows and state and county fairs. There were many award-winning farmers and ranchers in Norco.

Even though residents of Norco used horses on the farm to pull wagons and plows, horses always had a special place of honor and respect. As the city developed, it remained horse-friendly. A wagon is seen here traveling in the Hidden Valley area of Norco toward Arlington.

Mr. E. G. Barnes, a prominent citizen and large landowner, poses with baskets of large, ripe strawberries. Local farms contributed greatly to the economy by providing food and employment.

Many people of Dutch heritage settled the northern border of Norco, which was filled with cows and dairies. Known as Eastvale, this area remained a rural farming community for decades. It is projected that 10,000 homes will cover this once remote farmland over the next 10 years, and that Eastvale will become a city separate from Norco.

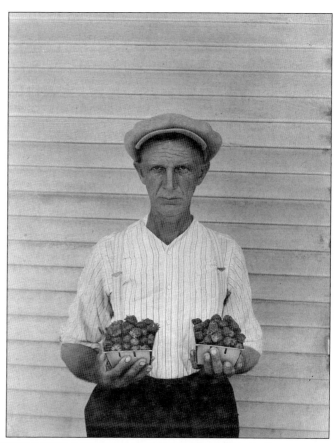

In the early 1900s, the land toward Mira Loma and Ontario supported cows and livestock while chicken ranches, like the one pictured, were located on the west toward Corona. Early ads promoted the area then called Corona Farms as the ideal location for little farms. Land was available on an eight-year payment plan with a one-tenth down payment. The enticing ads offered beautiful soil, a beautiful location, and cheap water. People leasing the land hoped to make the $2,000 a year from farming suggested by the ads.

Farm workers are seen on a large farm in early Norco. Both the California gold rush and improvements in the area's transportation system helped the city to grow. The Santa Fe Railroad brought people out west who were seeking inexpensive land and new opportunity. Norco was a two-hour car ride from Los Angeles.

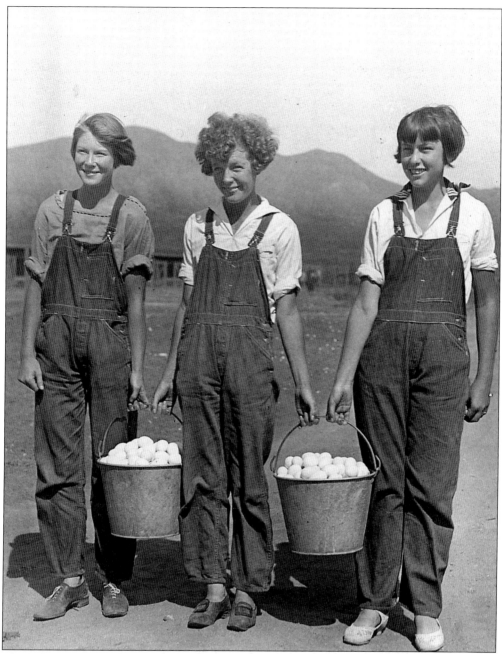

Three unidentified girls pose with buckets of eggs. Egg ranches were plentiful in Norco as they provided a good way for farmers to develop a profit from smaller plots of land. Many of the egg ranchers in the North Corona-Norco area were successful.

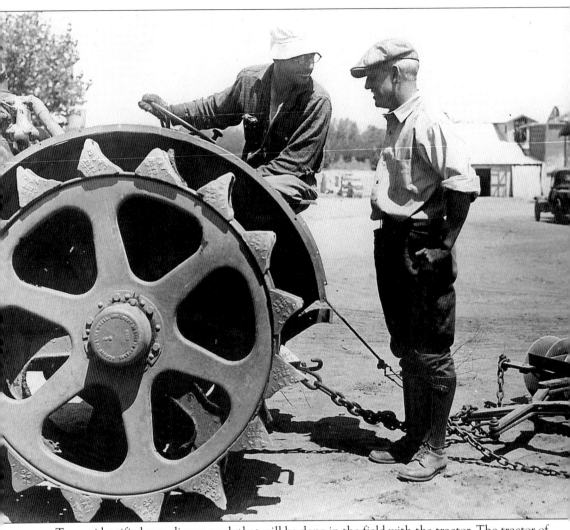

Two unidentified men discuss work that will be done in the field with the tractor. The tractor of the early 1920s helped to bring the industrial revolution to the farm and allowed farmers to do more work in less time.

Three
EDUCATION

Sierra Vista was the first school built in Norco. Before the school opened in 1951, Norco students had to attend school in Corona. The school opened with an office, a kindergarten class, and 10 other classrooms. With the growth of Norco and the arrival of more students, an additional kindergarten was added in 1956 along with nine more classrooms and a multipurpose room.

Mildred Whiteside Fluetsch, who taught for 36 years in Norco schools, recalls in her memoirs how developer Rex Brainerd Clark built the first school, called the Norco School, on Acacia Street. Today this original school is the Norco Community Center and is still used for a variety of events.

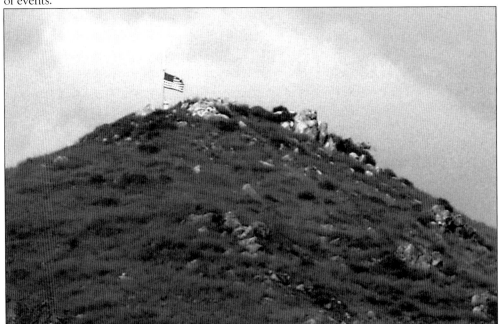

The location that Rex B. Clark selected for the first school was on the western side of Norco Valley just north of Beacon Hill, from which a bright light soared to the night sky inviting everyone who could see it to the new town being developed by Clark. In her memoirs, Mildred Fluetsch relates how children used to call the large hill the "chocolate drop." Today a flag takes the place of the beacon, which is now housed in the Norco Historic Society's museum.

This letter documents the establishment of Sierra Vista School. Today approximately 500 students attend the school.

CORONA-NORCO UNIFIED SCHOOL DISTRICT
300 BUENA VISTA AVENUE, CORONA, CALIFORNIA 91720 714/736-3301

DON HELMS, Ph.D., Superintendent
Telephone 714/736-3251

Shirley S. Mills, Asst. Superintendent
Educational Services/736-3341

Robert W. Crank, Asst. Superintendent
Business Services / 736-3431

Lee V. Pollard, Asst. Superintendent
Personnel & Evaluation Services / 736-3286

January 23, 1989

SIERRA VISTA ELEMENTARY SCHOOL
Norco's Oldest Existing School
by Mike Scanlon

Sierra Vista Elementary School, located at 3560 Corona Avenue, was built in two increments. The first construction consisted of an office complex, one kindergarten room and ten regular classrooms. These were built and ready for occupancy in 1951. Mrs. Mildred Fleutsch, who had been principal of Norco School, located in what is now the Community Center, was appointed the first principal of Sierra Vista.

The student population of unincorporated Norco grew so much, from 363 to 709, between 1951 and 1955, that it was necessary to enlarge Sierra Vista. In 1956, another kindergarten, nine classrooms and a Multi-Purpose Room were opened for use, and an army surplus bungalow was brought in to serve as a classroom. (The bungalow today serves as a library, a bi-lingual classroom and LSH room).

Mrs. Fleutsch retired in June, 1963, and Harold (Pete) Becker was appointed principal. Mr. Robert McCall (Lincoln Alternative School principal) served as Sierra Vista's administrator during the 66-67, and 67-68 school years; Dr. Rodney Mahoney was principal in 68-69, and the current principal, Mike Scanlon, was appointed in 1969.

Today there are approximately 500 students enrolled in Sierra Vista. Students, staff and the school have won many honors over the past 38 years, but the proudest moment came when Sierra Vista Elementary School of the Corona-Norco Unified School District was named a "California Distinguished School" in 1987 by the State Department of Education. This was an honor granted to only 245 schools out of more than 4500 elementary schools in California.

Board of Education
Charles H. Carter Sally L. Hoover Karen E. Stein
Louis VanderMolen Terry A. Young

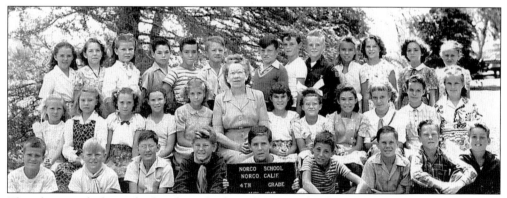

This photograph shows the fourth-grade class of Norco School in May 1948. In 2005, the school was awarded the honor of California Distinguished School by the California Department of Education for providing students with a quality education. A total of 1,200 seventh and eighth grade students attend a traditional school program with core academic subjects.

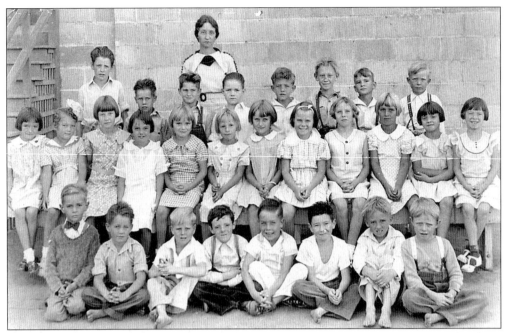

This photograph shows the second-grade class of 1935. The teacher is Alice Clegg. Today there are a total of 35 elementary and intermediate schools and seven high schools in the Corona-Norco Unified School District. Currently over 44,000 students are enrolled in the CNUSD and just over 5,000 teachers and support employees.

The Corona-Norco Unified School District was the first school district in the State of California to reduce class size at qualifying grade levels to a 20-to-1 ratio. Every class in grades K–3 and ninth grade math and English has no more than 20 students. The CNUSD has undergone several changes in its long history. In 1891, the school district had only three teachers and 319 students.

In 1991, Riverside Community College opened the Norco campus. It is fully accredited by the Western Association of Schools and Colleges and serves students who are working toward an associate degree after 60 units or approximately two years of study. Certificate programs and adult enrichment classes are also offered.

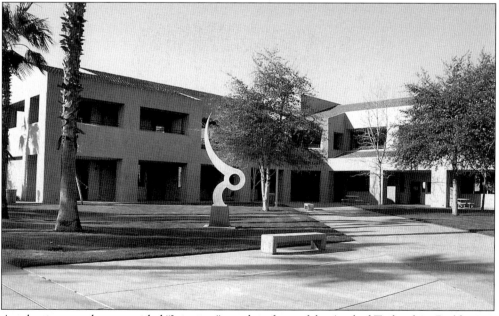

An aluminum sculpture entitled "Injection" stands in front of the Applied Technology Building on the Norco campus of Riverside Community College. Created in 2001 by artist Esmoreit Koetsier, the sculpture measures 32 by 168 by 56 inches. Esmoreit is a Dutch-born design engineer who resides in Lake Elsinore, California. He has numerous pieces on display in public places as well as in private collections.

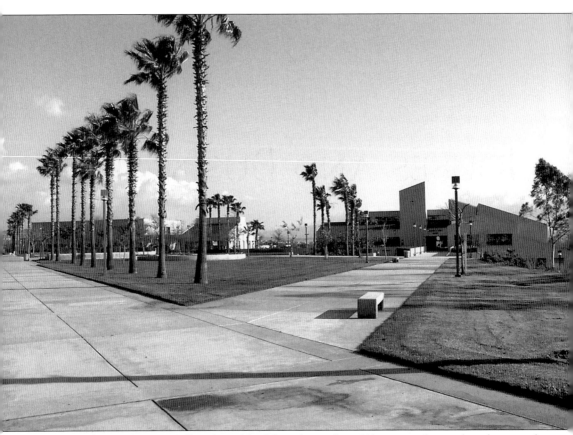

Riverside Community College has 10 buildings located on 141 acres and provides education for 8,400 students. Plans are in development to expand and accommodate more students in the coming years. It is part of the Riverside Community College District, which has been serving students in the area on three campuses for over 85 years.

Four
HOUSES AND BUSINESSES

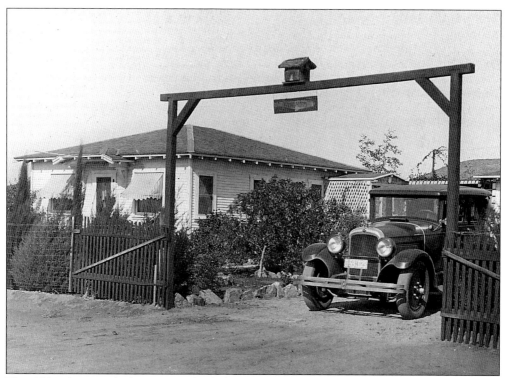

This 1924 photograph shows a wood-sided, single-story home that was typically built in Norco in the 1920s and 1930s. The sign above the driveway reads Rose Arbor. Along the left of the driveway are rosebushes in bloom while in the driveway is a fairly new automobile.

An unidentified man stands next to a home in Norco in the 1930s. The railroads brought many people from the Midwest to Southern California. The stylish awnings above the windows provided shade and helped to cool the house on hot summer days. These small bungalow-style homes were both attractive and affordable. This one is typical of the early homes that were built in Norco.

John Thomas Hamner was born in Alabama in 1887 and moved to Texas at an early age. A job on the railroad brought him west. He first settled in Corona in the area known as Orchard Heights, where he farmed on leased land, saving his money until he was able to purchase his own farmland. Eventually he owned over 1,000 acres in Riverside County. This photograph is of the Hamner home and headquarters.

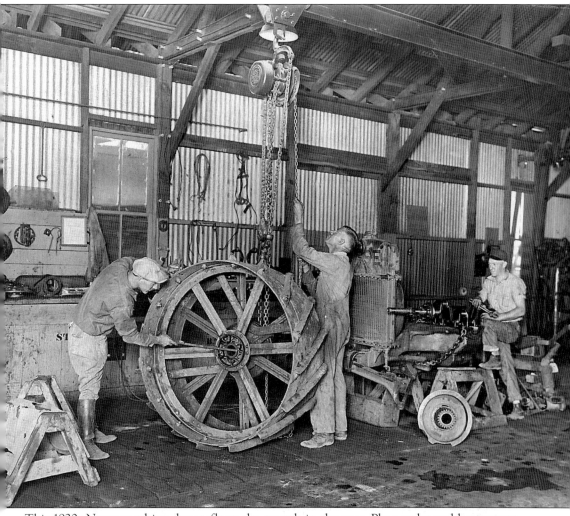

This 1920s Norco machine shop reflects the growth in the area. Plow mules and horses were replaced by machines, and shops were built to build and repair them. During World War II, many of the machine shops were needed to build tools for the war. These contracts helped the area to prosper.

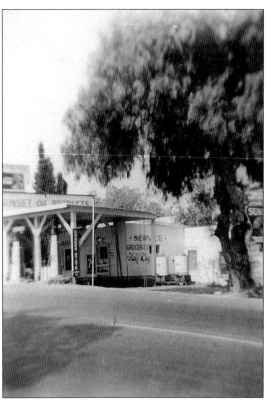

Beckmore Service Station and grocery store was located at Hamner and First Streets. The local store was very important to the community because there were no supermarkets in the 1930s and people shopped there for all of their household needs.

A procession of tractors in the late 1920s shows that progress is coming to Norco. These tractors are positioned and ready to start work on an irrigation system for the city. More water meant the possibility of more farms and expansion for the city as well as the development of the Norconian Club Resort.

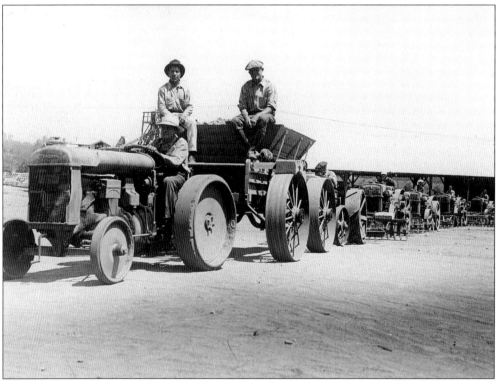

The sign at this roadside store advertises Sunset Products. By the 1930s, thousands of acres of oranges and citrus products were being grown in the Riverside and Corona area bordering Norco. The Sunset Fruit Company was built along the main line of the Atchison, Topeka, and Santa Fe Railway that ran between Los Angeles and San Bernardino.

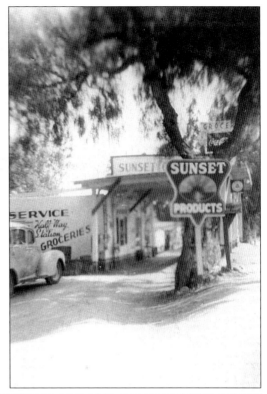

Two unidentified men in the early 1930s are seen at the Norco Lumberyard. As more people moved into Norco, the demand for lumber for building homes increased. As the area developed, small business such as this lumberyard gained more customers.

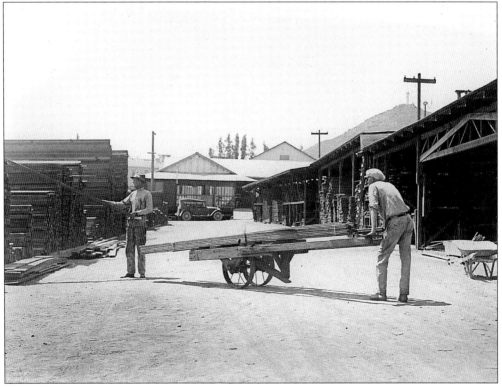

The classic California bungalow–style of home was popular in Norco from the 1890s through the 1930s. The style was affordable and suitable for the mild winters and warm summer months. The low-pitched roofs provided ample shade on warm sunny days while the homes conveyed a cozy, friendly atmosphere for residents and guests.

The Zeifuss farm, shown here in 1924, was typical of the early farms found in the Norco area. Most farms were about five to 10 acres in size and required a lot of work so that the farmers and their families could support themselves. Mr. Zeifuss was an early settler in Norco and arrived long before the founding of the city in 1964.

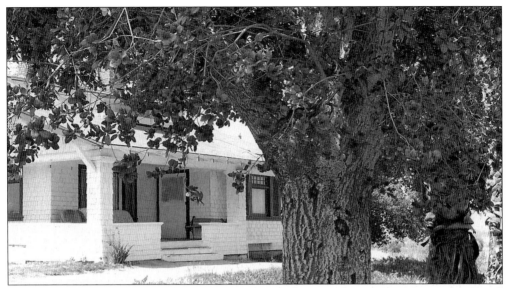

The Palmer-Moreno House, built in 1910, stands proudly as a tribute to the Moreno family and their contributions to horsemanship in the area. In 1978, this home was eligible to be included in the National Register of Historic Places. At one time, the Moreno family owned land that stretched from the Prado Dam near the City of Chino to Norco. This historic home is on 16 acres and serves as a living tribute to this prominent local family.

This is a modern photograph of Dr. Stoddard's Animal/Bird Veterinary Hospital on Hamner Avenue. It is believed to be the former home of Norco founder Rex Brainerd Clark. Clark was the first person to develop and advertise the city. He also owned a ranch in Julian, California.

Norco has been labeled by many as "Horsetown, U.S.A." Many of its homes are in rural zoning and have ample space for a horse or two. Horse trails are located behind a majority of homes in Norco, making it convenient for riders to open their back gates and start riding. Norco residents enjoy over 400 acres of park land and 95 miles of horse trails.

Five
LAKE NORCONIAN RESORT

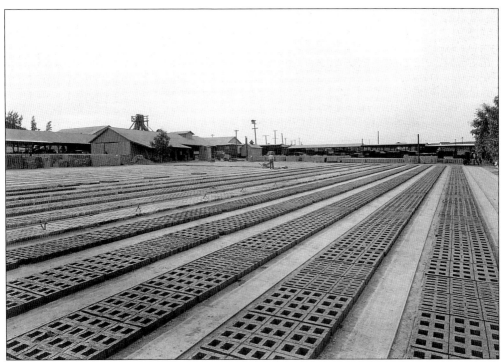

This 1920s photograph shows a large brickyard. During the construction of the Norconian Hotel, nearly 40,000 tile bricks were made a day. The demand for bricks was so great that they were used as fast as they were produced. Many jobs were created as a result of massive development started by founder Rex B. Clark.

After purchasing slightly over 5,000 acres, Rex B. Clark applied to the United States Patent Office for a trademark for the North Corona Land Company. In May 1928, Clark had offices both in Norco and in Los Angeles. This is a copy of U.S. Trademark No. 257,472.

Registered June 11, 1929.

Trade-Mark 257,472

UNITED STATES PATENT OFFICE.

NORTH CORONA LAND COMPANY, OF LOS ANGELES AND NORCO, CALIFORNIA.

ACT OF FEBRUARY 20, 1905.

Application filed May 23, 1928. Serial No. 266,876.

NORCO

STATEMENT.

To the Commissioner of Patents:

North Corona Land Company, a corporation duly organized and existing under the laws of the State of California, located at Los Angeles, California, and Norco, California, and doing business at 924 Roosevelt Bldg., Los Angeles, California, and Norco, California, has adopted and used the trademark shown in the accompanying drawing, for EGGS, FRESH VEGETABLES, FRESH DECIDUOUS FRUITS, in Class 46, Foods and ingredients of foods, and presents herewith five specimens showing the trade-mark as actually used by applicant upon the goods, and requests that the same be registered in the United States Patent Office in accordance with the act of February 20, 1905, as amended.

The trade mark has been continuously used and applied to said goods in applicant's business since May 13, 1928.

The trade mark is applied or affixed to the goods, or to the packages containing the same by means of a printed label and carton on which the trademark is shown.

The undersigned hereby appoints Jackson & Webster (a firm composed of H. M. Jackson and L. M. Webster), Russ Building, San Francisco, California, its attorneys, with full power of substitution and revocation, to prosecute this application, to make alterations and amendments therein, to transact all business in the Patent Office connected therewith, and to receive the certificate of registration.

[L. S.] NORTH CORONA LAND COMPANY,
By REX B. CLARK,
President.

The trademark for the North Corona Land Company was registered on June 11, 1929, one year after Rex B. Clark filed the application. According to the text of the registered patent, Clark planned to use the name for egg, vegetables, and fresh fruits labels and cartons. In addition, the wording on the patent shows that Clark had been using the business name since 1923.

No. 257472

The United States of America

To All To Whom These PRESENTS Shall Come:

This is to Certify That by the records of the UNITED STATES PATENT OFFICE it appears that NORTH CORONA LAND COMPANY, of Los Angeles, and Norco, California, a corporation organized under the laws of the State of California,

did, on the 23rd day of May, 1928, duly file in said Office an application for REGISTRATION of a certain

TRADE-MARK

shown in the drawing for the goods specified in the statement, copies of which drawing and statement are hereto annexed, and duly complied with the requirements of the law in such case made and provided, and with the regulations prescribed by the COMMISSIONER OF PATENTS.

And, upon due examination, it appearing that the said applicant is entitled to have said TRADE-MARK registered under the law, the said TRADE-MARK has been duly REGISTERED this day in the UNITED STATES PATENT OFFICE, to

North Corona Land Company, its successors or assigns.

This certificate shall remain in force for TWENTY YEARS, unless sooner terminated by law.

In Testimony Whereof I have hereunto set my hand and caused the seal of the PATENT OFFICE to be affixed, at the City of Washington, this eleventh day of June, in the year of our Lord one thousand nine hundred and twenty-nine, and of the Independence of the United States the one hundred and fifty-third.

Thomas E. Robertson
Commissioner of Patents.

ATTEST:
Law Examiner.

46

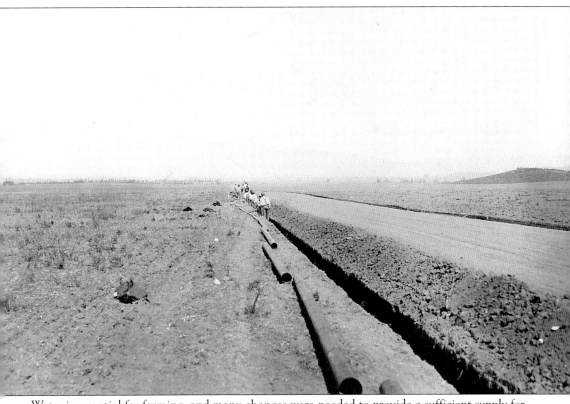

Water is essential for farming, and many changes were needed to provide a sufficient supply for the growing community of Norco. The land was surveyed, wells were drilled, and pipelines were laid. It was while Rex B. Clark was having irrigation wells dug to provide water for the farm parcels that workmen discovered an underground hot sulfur spring. Aware of the health benefits of mineral springs, Clark found a way to utilize this good fortune.

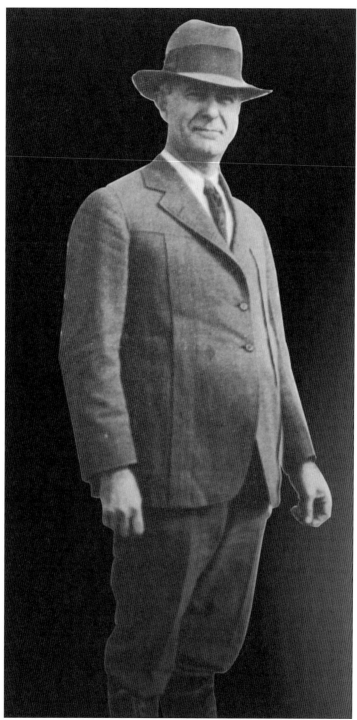
Rex Brainerd Clark was a man of ideas and action. He had the vision to see the potential in developing Norco, first by leasing large farms for a number of years to potential buyers. He also saw the possibilities of creating a place out of nothing and had the keen wisdom and ability to build a luxury resort that was ahead of its time. (Courtesy of U.S. Navy.)

Clark hired a civil engineer named Capt. Bert Gully to lay out the streets in Norco and design an improved water system. Gully served in World War I where he earned the rank of captain, a name that became his personal trademark. He and Clark made a great team, with Gully planning the city and Clark selling it by marketing its many assets and sense of luxury. (Courtesy of Glen Kaltenbrun.)

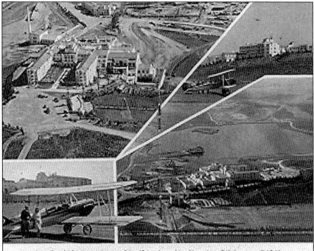

In 2000, Lake Norconian was added to the National Register of Historical Places. This street sign marks the event and provides directions to the facility. Since 1941, the 920-acre complex, including seven buildings, a pool, and the lake, has been owned by the U.S. government and has not been open to the general public. (Courtesy of U.S. Navy.)

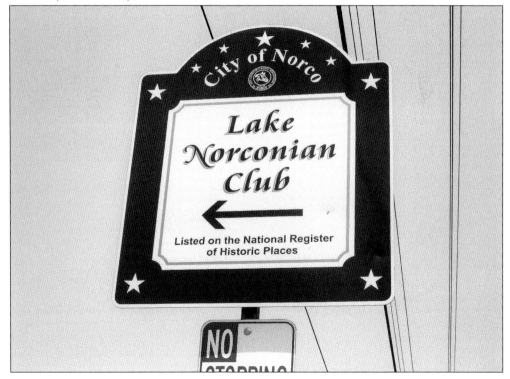

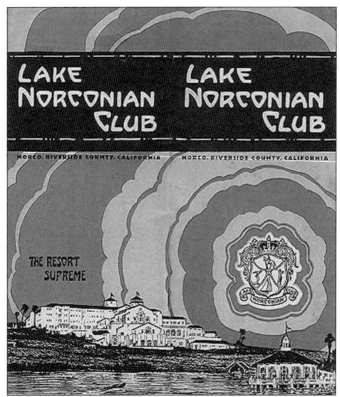

The Lake Norconian Club was a paradise for the rich and served as the "in" spot for leaders of business and society. Built on over 700 acres, it had lavish gardens, tennis courts, a golf course, a lake for boating and fishing, a casino, dancing, entertainment, hot mineral baths, gourmet dining, and luxury accommodations. The club's formal opening was held on February 4, 1929, just eight months before the stock market crash that started the Great Depression. The resort was able to operate for 12 years before Clark sold the complex. (Courtesy of Glen Kaltenbrun.)

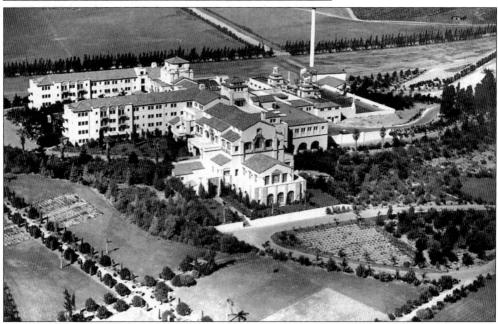

This aerial photograph provides a view of how vast the Norconian Club Resort and the surrounding property was—like a city within a city. The total projected cost to build the facility in 1927 and 1928 was approximately $4 million. In 1928, when the average annual salary was $1,300, a hotel room at the Norconian cost as much as $50 a day. (Courtesy of U.S. Navy.)

Aware that the 1932 Olympics would be held in Los Angeles, Clark in addition to the resort's indoor pools, constructed a double Olympic-sized pool with viewing stands for spectators. Several of the Olympic contenders used the pool for practice, but the location was never selected as a venue for the world famous games. (Courtesy of Glen Kaltenbrun.)

Many movies were filmed on location at the Norconian Club. The 1930 slapstick movie *Top Speed*, in which a poor office worker pretends to be rich and borrows a speedboat to complete this image, starred comedian Joe E. Brown. (Courtesy of U.S. Navy.)

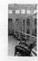
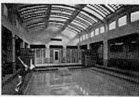

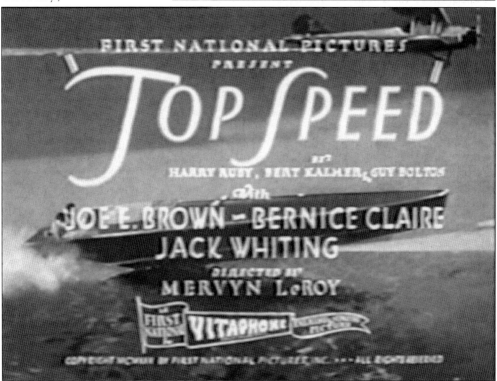

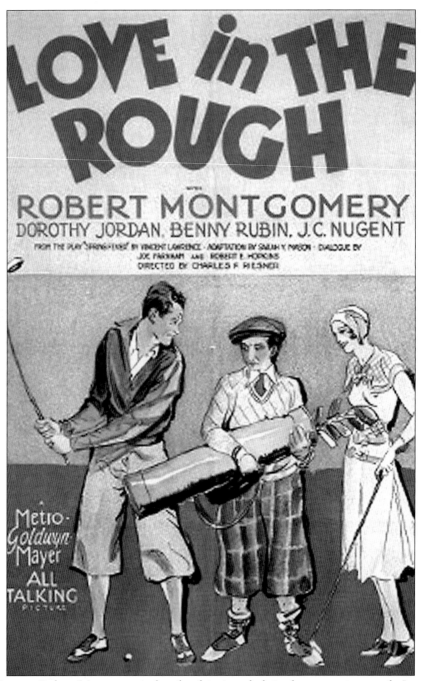

In 1930, actor Robert Montgomery played a shipping clerk in the romantic comedy *Love in the Rough*. His character wanted to win the attention of a rich woman so he posed as an executive to gain admission to an exclusive county club, where he bragged about being a good golfer. To his surprise, he won the country club's golf tournament. This movie was filmed on the golf course and grounds of the Norconian Club. Longtime locals remember the 1950s Guy Madison movie, *Charge at Feather River*, that was filmed in Norco on the banks of the Santa Ana River. (Courtesy of Glen Kaltenbrun.)

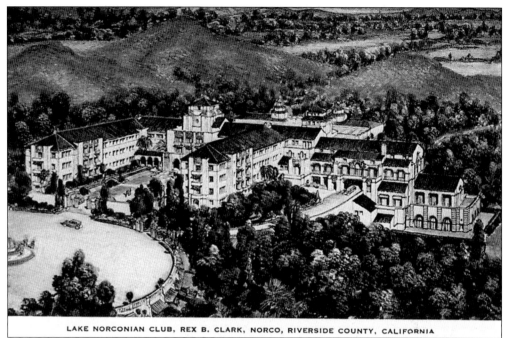

LAKE NORCONIAN CLUB, REX B. CLARK, NORCO, RIVERSIDE COUNTY, CALIFORNIA

The Spanish Mission Revival–style architecture of the complex was designed by Dwight Gibbs, a well-known architect in the Los Angeles area in the 1920s and 1930s. Gibbs also designed the 1,500-seat Carthay Circle Theatre in Los Angeles. Sadly, in 1970, the theatre was demolished. Rex B. Clark was married to Grace Messinger Scripps, heir to the Scripps fortune and the world famous Scripps Institute in northern San Diego. Clark and his wife had a ranch in the northern San Diego town of Julian.

Rex B. Clark knew how to promote his dream in words that would entice the right clientele. In a 16-page brochure, he compared the Lake Norconian Club to the palace at Versailles built by Louis XIV of France. The brochure mentions that the splendid arrangement of artistic furnishings would provide visitors with an atmosphere for undisturbed tranquility. (Courtesy of Glen Kaltenbrun.)

Rex B. Clark published many elaborate photograph albums and brochures, often using Hollywood models and stars to interest people in visiting the luxury resort hotel. A quote from one of these brochures stated, "The most unusual and delightful place in the West. Where climate, scenery and hospitality are best—all year round." (Courtesy of Glen Kaltenbrun.)

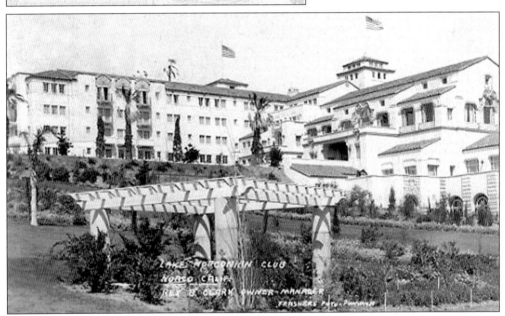

In 1941, the U.S. Navy bought the hotel and the surrounding buildings and land. During the war years, the former luxury hotel was refurbished as a naval hospital. Today there is a major division in the property and surrounding land. In 1962, when there was no longer a need for the former hospital, the federal government offered it to the State of California. The once elite Norconian Hotel is now run by the California Department of Corrections as a hospital and facility for men and women incarcerated for drug addiction. (Courtesy of Glen Kaltenbrun.)

Six
THE NAVY

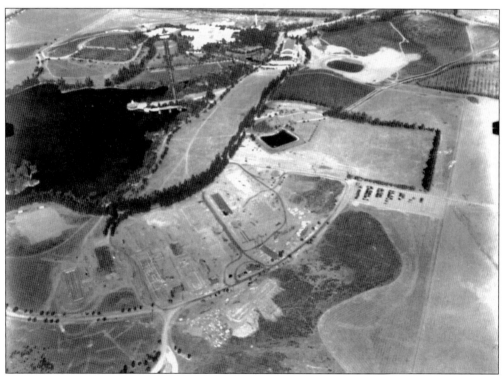

This aerial view of the Norconian Club shows how it looked when it was sold to the Navy in 1941 and gives an insight to the vast size of the property, which included a 58-acre lake and an airport with two dirt runways. The longer of the two had a 2,400-foot east-west strip. (Courtesy of U.S. Navy.)

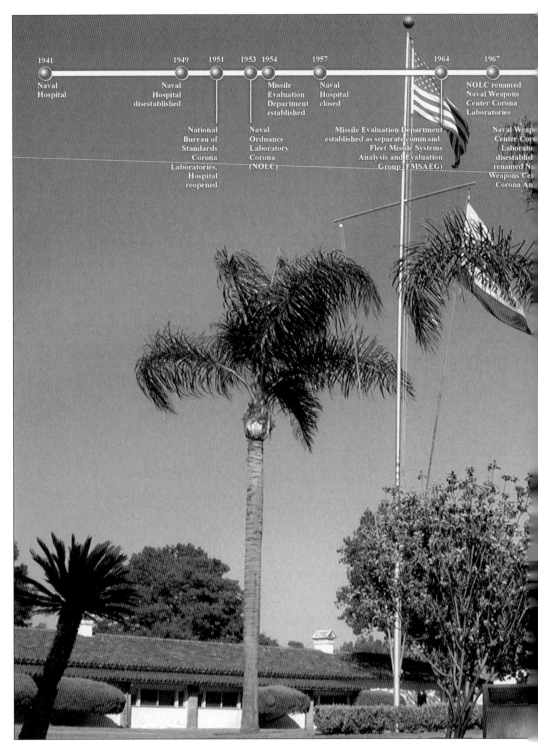

The U.S. Navy has had a long history in the city of Norco. This chart marks the timeline of the Navy's presence at the Corona-Norco facility, beginning in 1941, when the luxury Norconian Resort was sold to them. The facility was used as a hospital, then closed for a period of time and

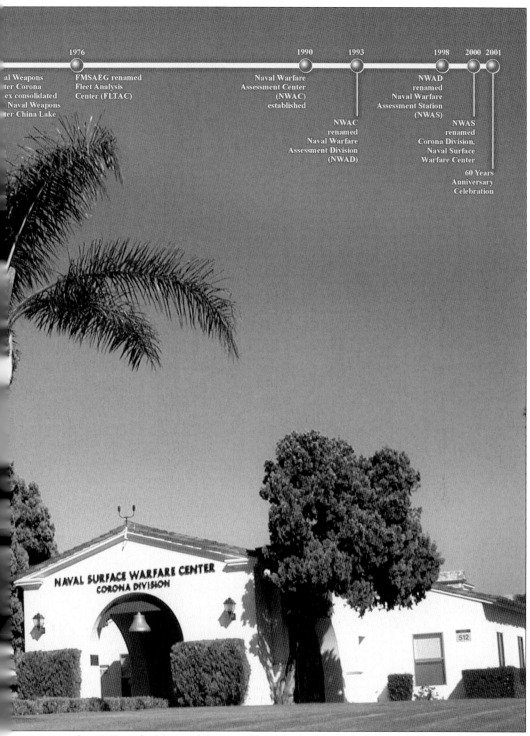

reopened in 1951 as the National Bureau of Standards Corona Laboratories Hospital. The facility received its final name in 2000 when it became the NWAS Corona Division Naval Surface Warfare Center. (Courtesy of U.S. Navy.)

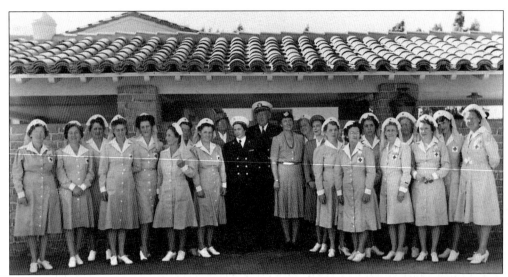

The transformation of the once famous luxury resort to a naval hospital took place immediately following the attack on Pearl Harbor, December 7, 1941. During World War II, Frank Knox, secretary of the Navy, commissioned the Norconian resort as a hospital ship. In 1943, Captain and Mrs. Jensen and the Grey Ladies stand in front of the new tuberculosis unit. (Courtesy of U.S. Navy.)

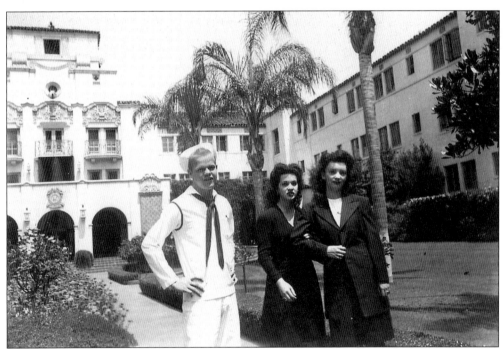

Familiar sights at the naval hospital ship were men and women in uniform greeting guests who visited the facility. Ted Quillen is pictured with visitors from Los Angeles. Quillen, who provided this photograph to the Navy, was one of hundreds of sailors recovering from rheumatic fever who was sent to the Norco Naval Hospital from the Naval Air Tech Center in Memphis. (Courtesy of U.S. Navy.)

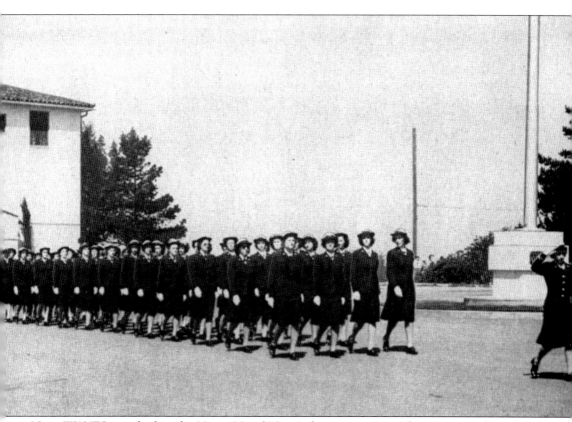

Navy WAVES attached to the Norco Naval Hospital pass in review. The name was short for Women Accepted for Volunteer Emergency Service, which was a unit of the U.S. Naval Reserve. By 1945, nearly 86,000 women had enlisted in the WAVES. Those who were stationed in the United States assisted with clerical duties, nursing, and rehabilitation therapy for returning troops. (Courtesy of U.S. Navy.)

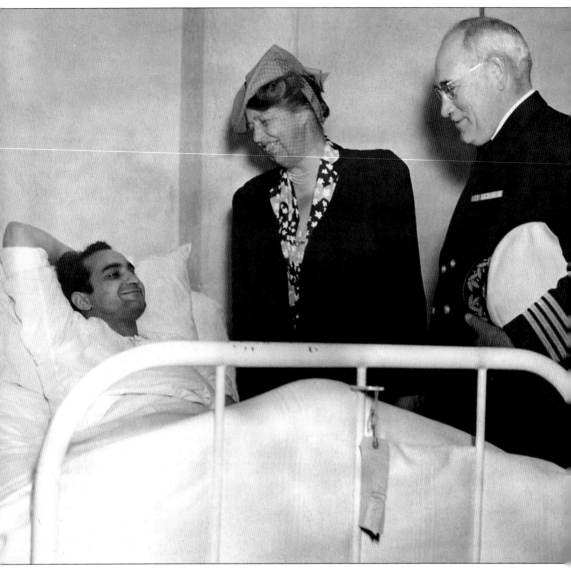

During World War II, First Lady Eleanor Roosevelt visited patients at the naval hospital in Norco. An unidentified patient and unidentified naval officer are shown here with Mrs. Roosevelt. She served as first lady from 1933 to 1945 and traveled to all parts of the United States, greeting thousands of people with warmth and friendliness. (Courtesy of U.S. Navy.)

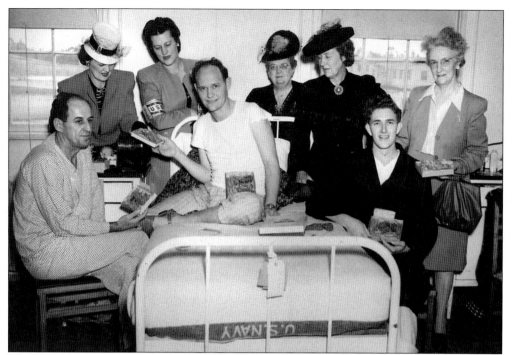

Members of the USO visit with patients at the Norco Naval Hospital during World War II. The USO (United Service Organizations) was created in 1941 as The Salvation Army, YMCA, YWCA, National Catholic Community Services, National Jewish Welfare Board, and the National Travelers Aid Association joined together to provide recreation for military troops on leave. The USO is a private, nonprofit civilian service organization. (Courtesy of U.S. Navy.)

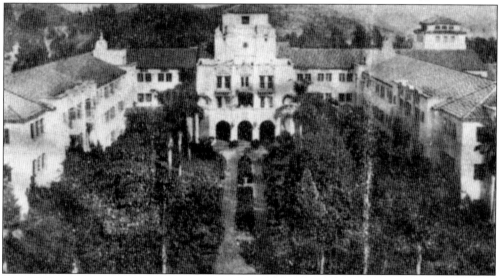

The 1947 newspaper article accompanying this picture described the naval hospital as a big asset to the city of Norco in addition to providing for the health and welfare of war veterans. In 1944, during the peak of World War II, the hospital treated 4,500 patients for polio, rheumatic fever, and tuberculosis, and also performed surgery. By 1947, the hospital was only treating 1,200 patients a year. (Courtesy of U.S. Navy.)

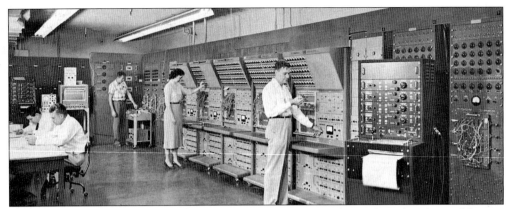

The naval hospital closed in 1949, but when the facility reopened in 1951 as the National Bureau of Standards, the hospital reopened as well. In 1953, the facility had a name change to Naval Ordnance Laboratory Corona and reopened with a staff of 400. Even though the facility is in Norco, it has always been called the Corona facility. In 1954, the facility became the Missile Evaluation Department. Here unidentified workers analyze the analog computer's information, which had a precision of three or four significant figures. (Courtesy of U.S. Navy.)

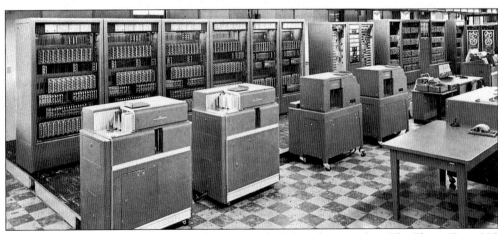

The Missile Evaluation Department's function included tracking quality. The ElectroData 205 computer system was used to collect data, which was stored at the central data processing facility. (Courtesy of U.S. Navy.)

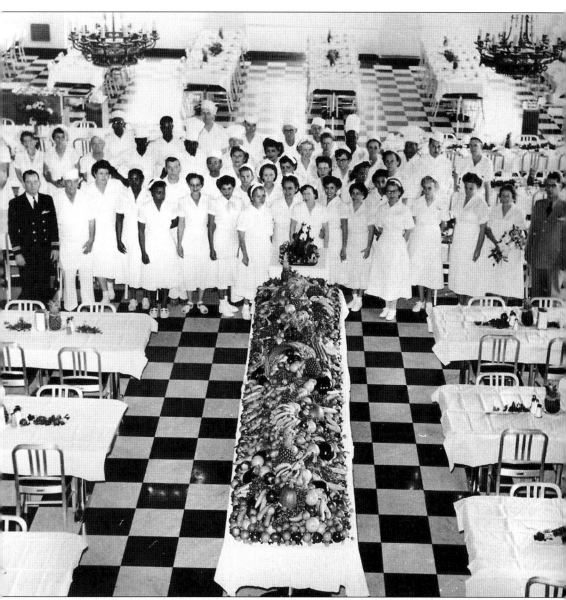

The cafeteria staff at the naval hospital pose in the main dining room for this early-1950s photograph. A table is piled high with a lavish assortment of fresh fruits. In October 1957, the facility was given to the General Services Administration for disposal. In March 1962, Gov. Edmund G. Brown announced that the federal government had donated part of the property and grounds to the State of California for a rehabilitation facility for convicted narcotics addicts. (Courtesy of U.S. Navy.)

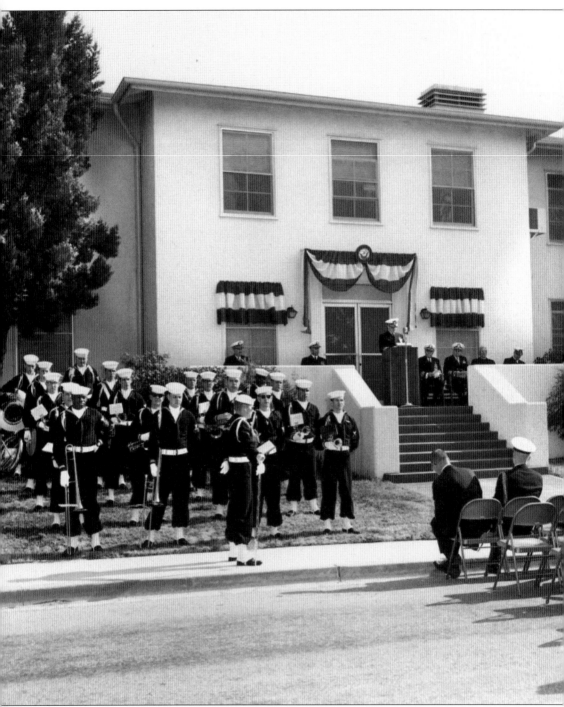

In 1964, the Secretary of the Navy established the U.S. Naval Fleet Missile Systems Analysis and Evaluation Group (FMSAEG) and reopened the facility for the purpose of evaluation of performance, reliability readiness, and effectiveness of missile weapon systems and associated test equipment. A Navy band played at the FMSAEG to celebrate the change of commanding officers from Comdr. Glen Estes Jr. to Commander Heiler in February 1966. (Courtesy of U.S. Navy.)

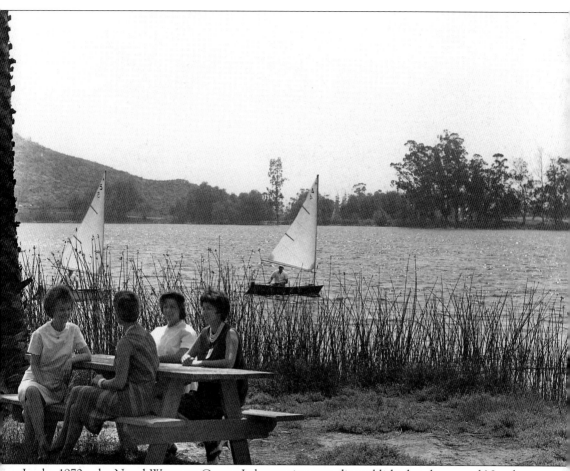

In the 1970s, the Naval Weapons Center Laboratories were disestablished and renamed Naval Weapons Center Corona Annex. The man-made lake built by Rex B. Clark still remains and provides a place for rest and relaxation for workers at the facility. Here employees enjoy the grounds and sailing on Lake Norconian. (Courtesy of U.S. Navy.)

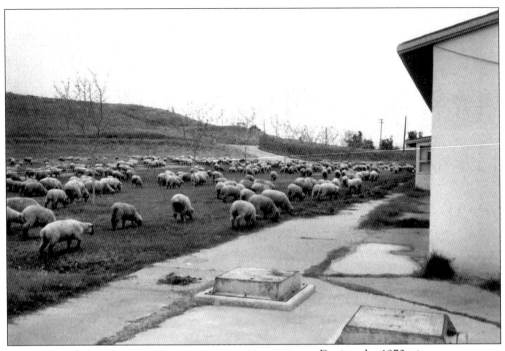

During the 1970s, it was common to see sheep grazing on the base of the Naval Weapons Center. It was a pleasant sight for employees at the base and a break from the routine of work. The sheep's grazing helped with the maintenance by keeping the grass trimmed. (Courtesy of U.S. Navy.)

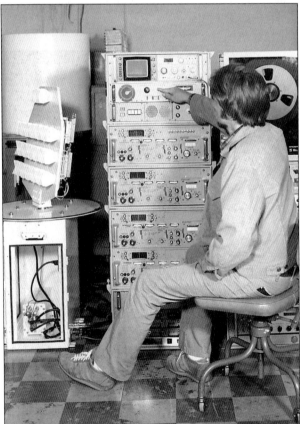

In 1976, the Norco-Corona base of the former U.S. Naval Fleet Missile Systems Analysis and Evaluation Group (FMSAEG) was renamed the Fleet Analysis Center as the Navy took steps to consolidate their work in the greater Los Angeles area. The FMSAEG became an annex of the Seal Beach Weapons Station, and the Norco facility was renamed to reflect its changing function. In May 1980, an engineer shows off new test equipment. (Courtesy of U.S. Navy.)

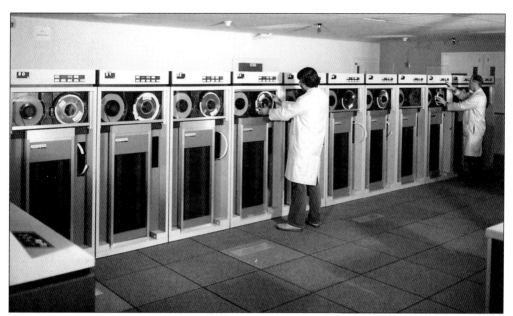

Analysts add tape to a computer in December 1980. The mainframe computer was used in the late 1970s and early 1980s. The memory and control units of these large mainframe computers were housed in small cabinets that were grouped together. The early mainframe computers were used either for data processing or for analysis of engineering and scientific data. Most of the early computers were not compatible, and the small-sized PC computers common today did not exist. (Courtesy of U.S. Navy.)

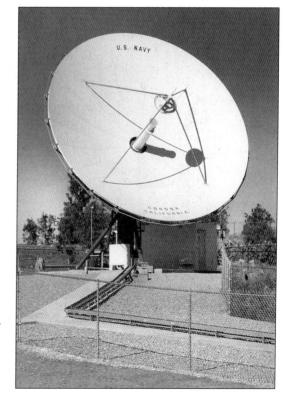

This is the Satellite Earth Station on the Norco-Corona base of the Fleet Analysis Center. The Norco facility is connected to every major naval facility, including Hawaii and Puerto Rico and several other Department of Defense locations through high-speed data lines, fiber optic systems, and satellite technology. (Courtesy of U.S. Navy.)

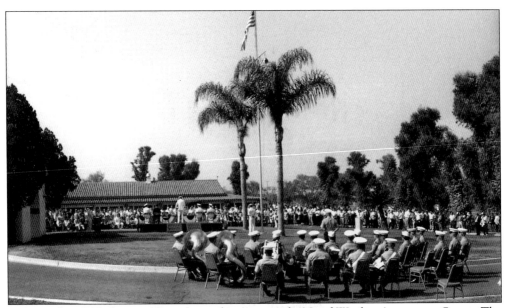

In September 1990, the naval base changed its name to the Naval Warfare Assessment Center. The name was changed to better reflect the major business components of the facility: measurement science, missile and combat systems performance assessment, and product quality assurance. This formal ceremony was held for the redesignation of the facility. (Courtesy of U.S. Navy.)

A formal groundbreaking ceremony was held and plans were unfolded for future construction. The 48,000-square-foot Warfare Assessment Laboratory theatre was designed for flexible use and can be configured to seat up to 200 in theatre-style seating, or can be set up with workstations for interactive analysis. In either arrangement, computer and video signals come from many sources. (Courtesy of U.S. Navy.)

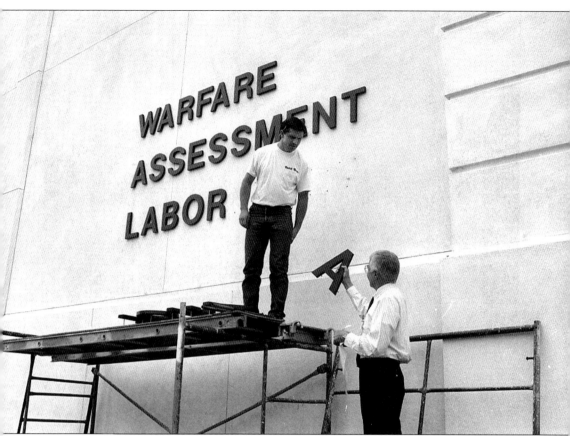

Due to a 1993 realignment, the Navy changed the name of the Naval Warfare Assessment Center to Naval Warfare Assessment Division. The NWAD was able to provide improved integrated analytical support to naval fleet and shore organizations. In April 1994, the Warfare Assessment Laboratory was completed. (Courtesy of U.S. Navy.)

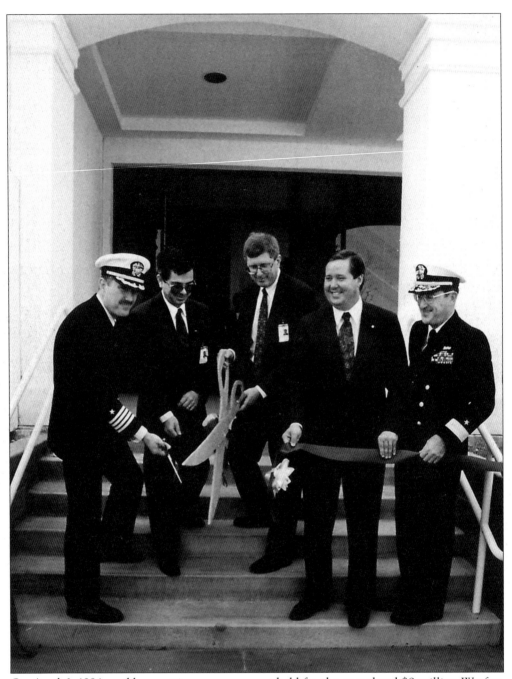

On April 6, 1994, a ribbon-cutting ceremony was held for the completed $9 million Warfare Assessment Laboratory. In the photograph, from left to right, are Captain Schwier, Bob Beavan, Dr. Wayne Meeks, Congressman Ken Calvert, and Rear Admiral Sutton. The facility houses a state-of-the-art presentation theatre that can be used for standard meetings and demonstrations, real-time displays, and interactive analysis of flight training or other information. (Courtesy of U.S. Navy.)

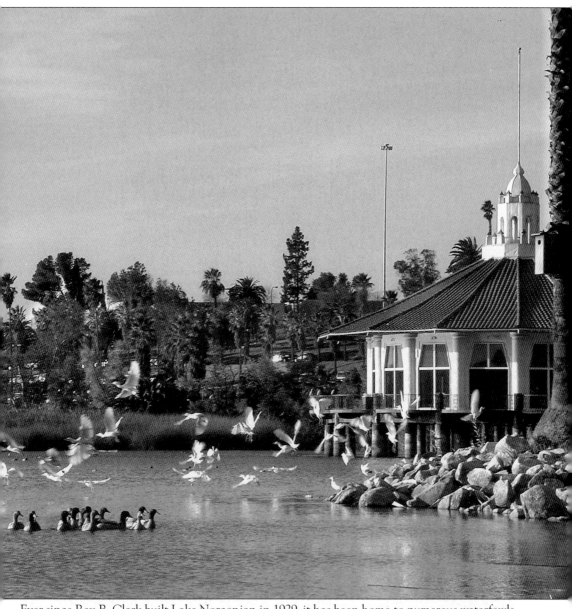

Ever since Rex B. Clark built Lake Norconian in 1929, it has been home to numerous waterfowls and other wildlife. Geese, ducks, rabbits, squirrels, dragonflies, snakes, and turtles all call the lake home. This tranquil scene from December 2000 shows birds taking flight over the lake. (Courtesy of U.S. Navy.)

In 2001, the Naval Warfare Assessment Division was renamed Corona Division, Naval Surface Warfare Center, part of the NAVSEA. With the name change, the signs on the buildings also needed to reflect the change. The name on the Command building is seen here in the process of being changed. (Courtesy of U.S. Navy.)

In 2001, landscaper Brian Schmidt installed the naval name change at the Fifth Street entrance. It is the mission of the NAVSEA to "gauge the war-fighting capacity of ships and aircraft by analyzing design, performance, and training." The facility has created an innovative relationship with local colleges. (Courtesy of U.S. Navy.)

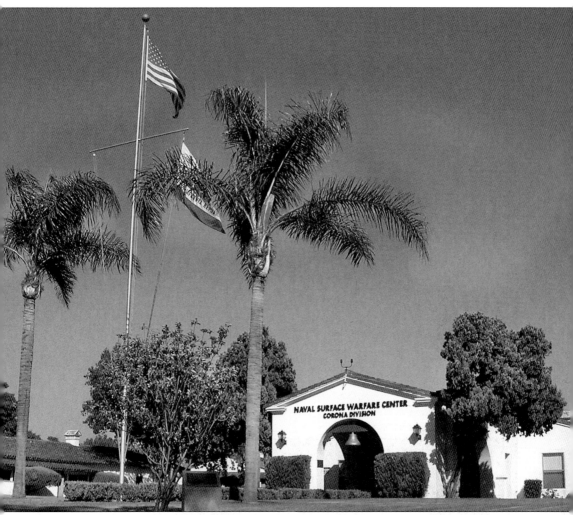

The U.S. flag flies in the afternoon breeze in front of the Naval Surface Warfare Center. Nearly 1,000 scientists and engineers and 700 civilian contractors work at this large Navy facility, which is responsible for more than $146 million in revenue to the Inland Empire each year. (Courtesy of U.S. Navy.)

In November 2001, the Lake Norconian Club got a makeover, the first in 72 years, with repairs, cleaning, and painting. When Rex B. Clark built the Norconian Club Resort, all of the fixtures and furnishing looked as if they were from castles in Spain and Italy. (Courtesy of U.S. Navy.)

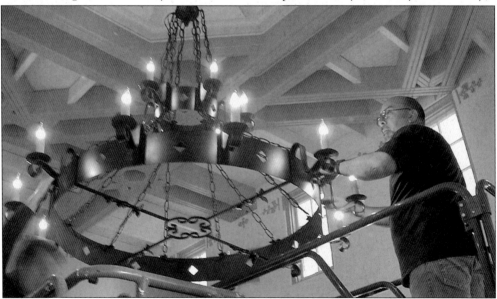

A new chandelier was installed in the Norconian Club that was designed to resemble the original. In 2000, the Lake Norconian Club was added to the National Register of Historic Places. (Courtesy of U.S. Navy.)

This 1929 photograph shows the original chandelier that hung in the Norconian Club. The new chandelier that replaced it was carefully created to resemble the original. Through the years the club has been used for wedding and banquets for members of the Navy and local clubs and organizations in the Norco-Corona area. (Courtesy of U.S. Navy.)

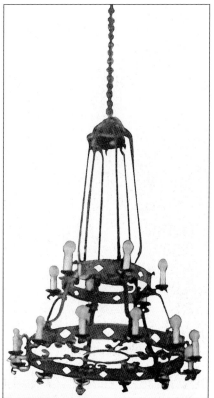

Two fishermen spend a quiet afternoon fishing at Lake Norconian. The lake has an ample supply of bluegill, bass, and catfish. Navy and civilian employees who have worked on the base since 1941 have had the rare opportunity to enjoy the peace and tranquility of this isolated lake. (Courtesy of U.S. Navy.)

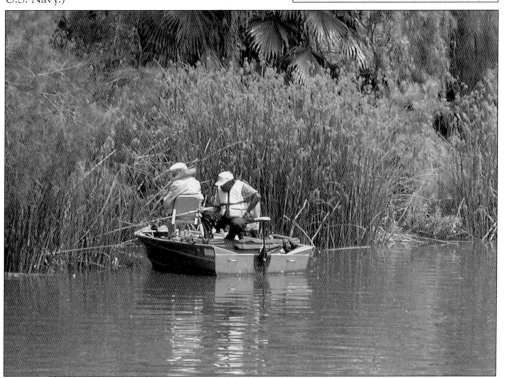

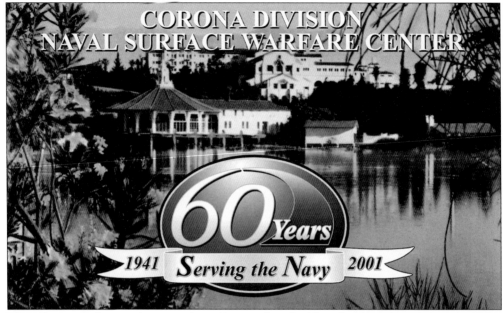

This illustration honors the more than 60 years that the Navy has been based in Norco. This postcard was a reproduction of an original from the late 1920s that was created to commemorate the 60th anniversary at this facility. (Courtesy of U.S. Navy.)

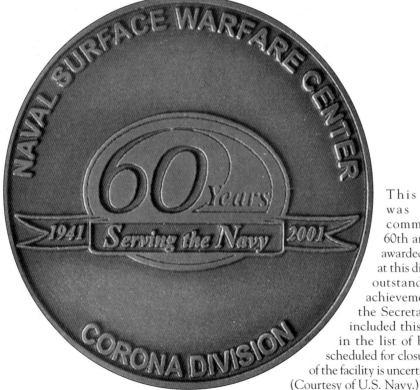

This medallion was created to commemorate the 60th anniversary and awarded to employees at this division for their outstanding personal achievements. In 2005, the Secretary of Defense included this naval facility in the list of bases that are scheduled for closure. The future of the facility is uncertain at this time. (Courtesy of U.S. Navy.)

Seven
CHURCHES

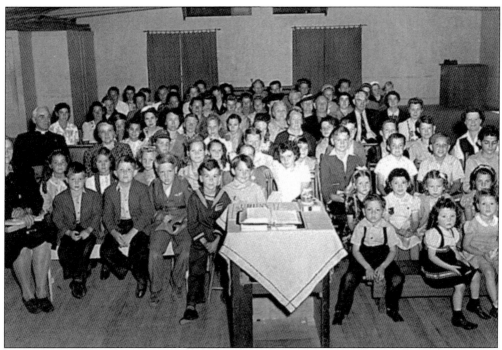

Established in 1959, St. Mel's Catholic Church was under the jurisdiction of the Bishop of San Diego, the Most Rev. Charles Francis Buddy. In 1978, St. Mel's became part of the newly formed Diocese of San Bernardino. In 2005, there were 1,344 register parishioners. The parish has several organizations that help both in the church and in the community.

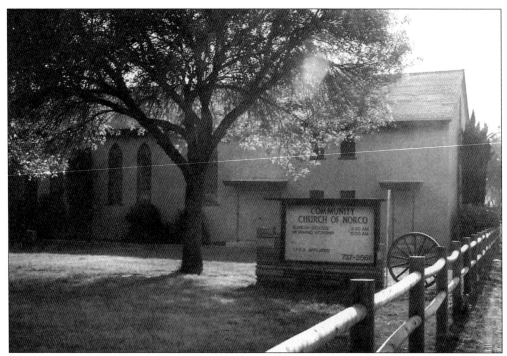

The Community Church of Norco, located on Valley View Avenue, was established in the 1920s and incorporated in 1947. It is a nondenominational church and since 1956, has been affiliated with the Independent Fundamental Churches of America. Established in 1930, the IFCA is an association of Bible-believing churches and individuals that seek to proclaim the Gospel of Christ.

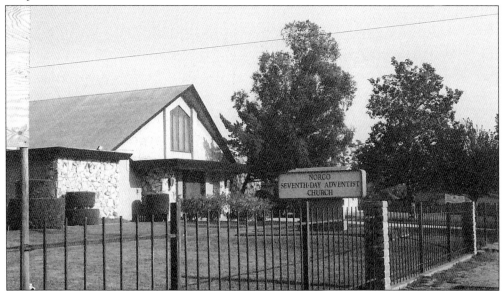

In 1960, the Norco Seventh Day Adventist Church was established. When the church was first organized, services were held in the Community Center Building. Today the church is located on five acres of land off of Corona Avenue on the east side of town. Dedication of the current church was in December 1970.

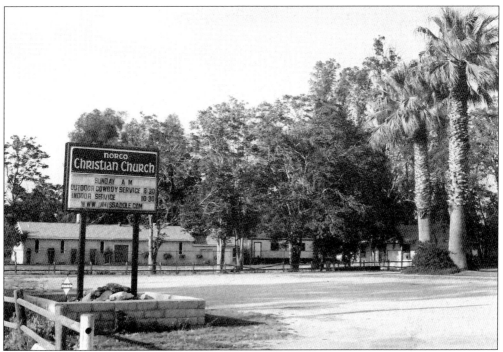

The Norco Christian Church on Corona Avenue opened in 1989 as a horse friendly church. Worshipers are able to ride their horses to church, and the church provides a country-worship atmosphere with regular indoor services each Sunday as well as an outdoor cowboy service. The church has many special ministries and outreach programs.

The Church on the Hill is a nondenominational Reformed Church in America centered in Christ and believing that the final authority of their faith is the Holy Scripture. The Norco church is in a beautiful location on the top of Norco Drive overlooking the entire city.

The Norco Church of Christ is at the end of Sixth Street near Ingalls Park. Also on Sixth Street is Grace Fellowship Church, which offers something for every age group. The slogan of Grace Fellowship is "A Great Commitment to the Great Commandment and the Great Commission will grow a Great Church." Over 30 churches are currently located in Norco. Many were established before the 1964 incorporation of the city. In 1924, the North Corona Land Company opened the city's first auditorium. It provided space for civic meetings, Sunday school, and church services.

Rev. Bob Harris is associated with Cowboy Church International and has been on the staffs of the Crystal Cathedral, the "Hour of Power" TV show, and the Christian Broadcasting Network's 700 Club. Through the Good Company Rodeo Ministries, Reverend Bob travels to rodeos and Western events to share the message of God in a simple fashion. (Courtesy of R. W. Laurence.)

Eight
MAYORS, BEAUTY QUEENS, AND RODEOS

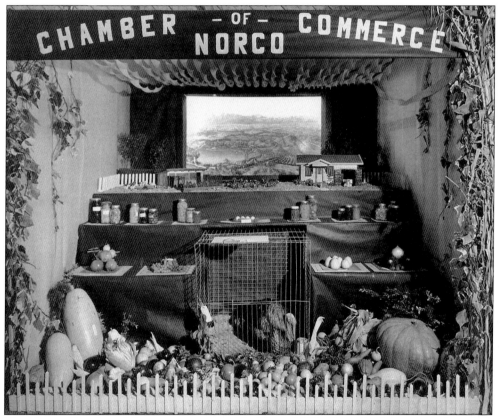

The Norco Chamber of Commerce sponsors the Norco Valley Fair, which was started in 1947. A growing number of locals and visitors enjoy this annual event. In this early fair photograph, a vast assortment of the bountiful harvest grown in Norco is displayed. In the background is an illustration of the entire Norco Valley with Lake Norconian in the foreground. Canned goods, pumpkins, squash, corn, pomegranates, and grapes are all ready for the judges.

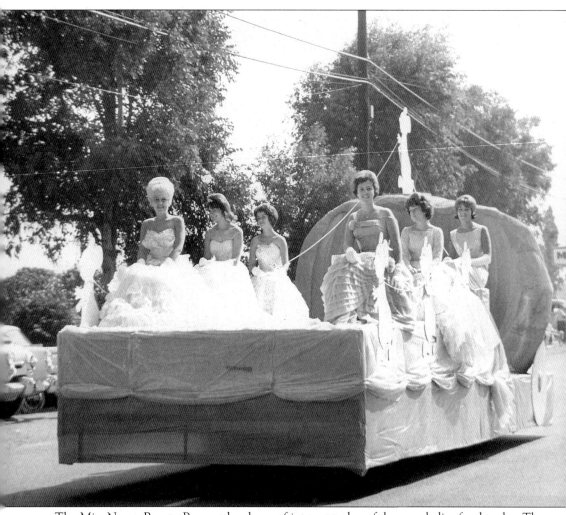
The Miss Norco Beauty Pageant has been of interest to hopeful young ladies for decades. The title of Miss Norco is a respected position in the community.

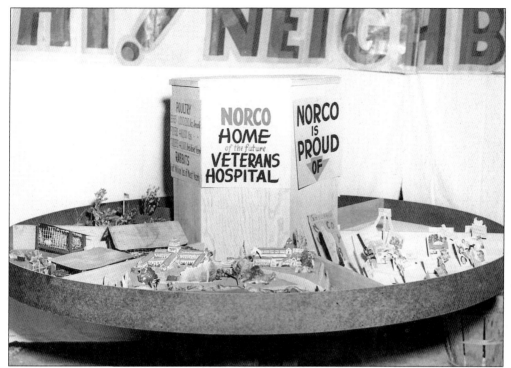

The citizens of Norco were proud to have the Navy hospital as a neighbor. This Norco Valley Fair entry celebrates the start of the relationship between the Navy hospital and the City of Norco. The hospital opened during World War II.

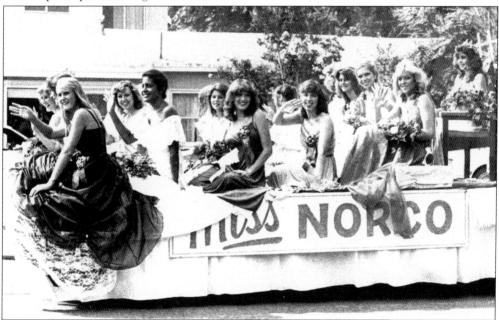

An early Norco queen and her court ride on a parade float. Traditionally Norco has several parades each year. One is during Horse Week and another is on Labor Day. The Norco queen has the honor of riding on a float in each of these city parades.

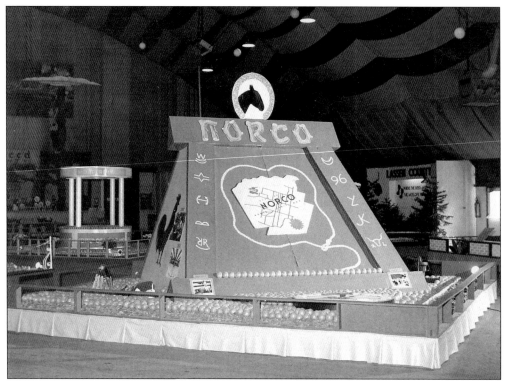

Since the early days of Norco, ranchers branded their cattle and horses in order to retrieve stray livestock and to discourage cattle rustling. Locals knew what cattle ranchers owned by their brand. This display at a California fair honors early cattle brands that were well-known in Norco.

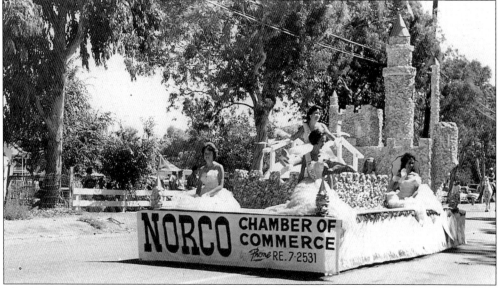

Miss Norco is a goodwill ambassador for the city—the queen and her court have a place of honor in the city of Norco for a year. They ride in parades, attend grand openings, and participate in many community events. In recent years, young ladies who hold the title of Miss Norco have the opportunity of winning scholarship money.

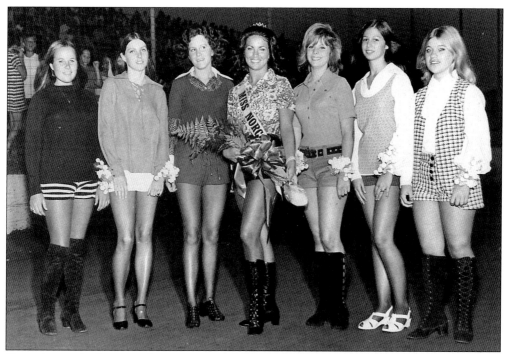

Short-shorts, also known as hot pants, were the fad in the 1970s. This Norco queen and her court dressed in the latest fashion of the times.

Contestants on the runway compete for the title of Missile Queen 1964 U.S. Navy Fleet Missile Systems Analysis and Evaluation Group. Stella Magana (far right) was crowned queen. (Courtesy of U.S. Navy.)

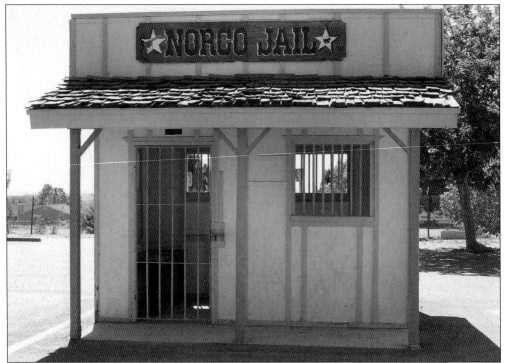

Each candidate for Miss Norco has to sell a required number of buttons sponsoring the Norco Valley Fair. During the fair, all visitors who do not display the fair button visit the "special" jail where they are given an opportunity to buy a fair button and buy their way out of jail. It is all in good fun.

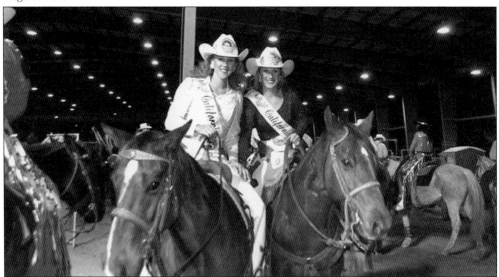

Norco is home to many regional and national rodeo events. Women who earn the title of Miss Rodeo California appear at many rodeos during their reign along with their royal court. They also assist with charity work in their local communities and throughout the State of California. These lovely ladies visit the sick and elderly in nursing homes and assist with handicapped children's rodeo events. (Courtesy of R. W. Laurence.)

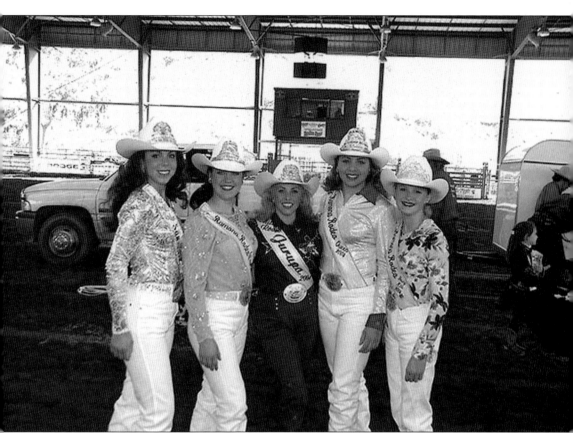

Contests to select Miss Rodeo California are first held at a local level before the winners have the opportunity to attend the statewide competition. The rodeo queen and court are not only judged for beauty, poise, and grace but also for their horsemanship. They have to be knowledgeable about horses and the rodeo industry. The queens serve as goodwill ambassadors at various rodeos held throughout the state during their reign. (Courtesy of R. W. Laurence.)

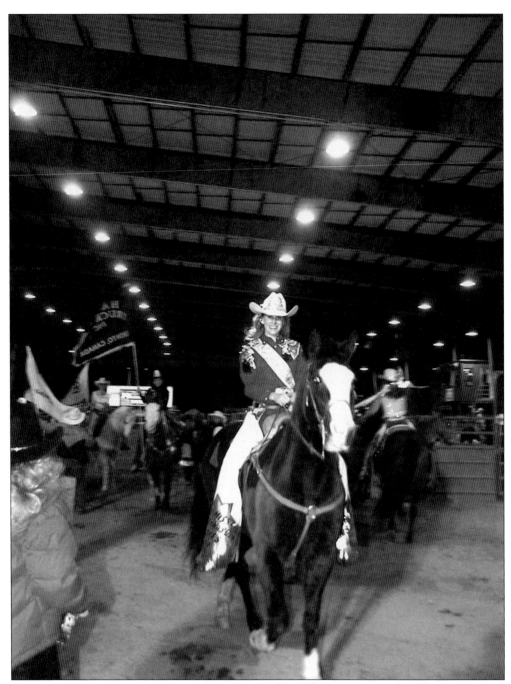
Current and past winners of the Miss Rodeo California have to be comfortable in an arena. These special ladies often make public appearances and have to be able to speak in front of both large and small audiences. Public appearances are arranged through the Miss California Rodeo organization (http://www.missrodeocalifornia.com). The ladies participate in roping events and barrel racing and also model Western wear. The contestants usually are working on college degrees and are able to benefit from the scholarship prize money that they earn competing in the pageant. (Courtesy of R. W. Laurence.)

Gilbert Cox was mayor of Norco from 1964 to 1966, serving as the first mayor following the city's incorporation. (Courtesy of City of Norco.)

Louis Hoefs was mayor of Norco from 1966 to 1967. (Courtesy of City of Norco.)

Dr. John Koning was mayor of Norco from 1967 to 1968. (Courtesy of City of Norco.)

O. M. Taylor was Norco's mayor from 1968 to 1969. (Courtesy of City of Norco.)

Ivan Warrick was mayor of Norco from 1969 to 1971. (Courtesy of City of Norco.)

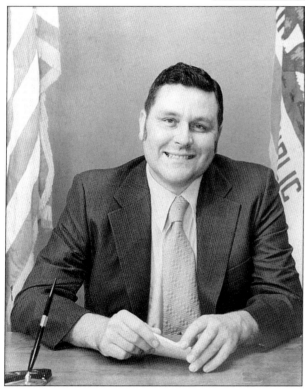

From 1971 to 1972, veterinarian Dr. William H. K. Herron was mayor of Norco. (Courtesy of City of Norco.)

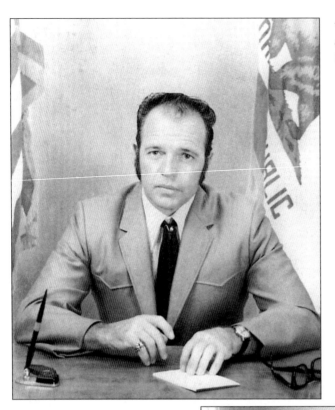

William Jarrett was mayor of Norco from 1972 to 1973. (Courtesy of City of Norco.)

Harry W. Brinton was mayor of Norco for two terms, from 1974 to 1975 and from August 1977 to March 1978. Together with his wife, Eleanor, Brinton chaired the study for the chamber of commerce regarding the impact of Interstate 15's planned route through Norco. (Courtesy of City of Norco.)

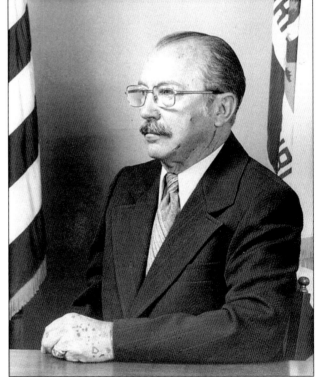

Veterinarian Dr. Richard J. Brown was mayor of Norco from 1975 to 1976. (Courtesy of City of Norco.)

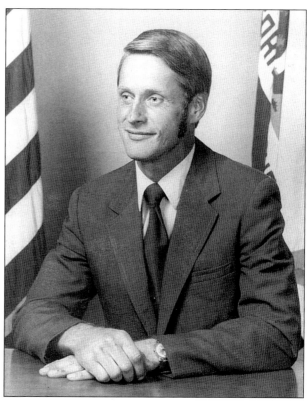

Jerry Riley was mayor of Norco from March 1977 to July 1977. (Courtesy of City of Norco.)

From 1978 to 1979, Lori Gregg was Norco's mayor. (Courtesy of City of Norco.)

F. R. "Phil" Jones was mayor of Norco from 1979 to 1980. (Courtesy of City of Norco.)

Nine
Horses and Riders

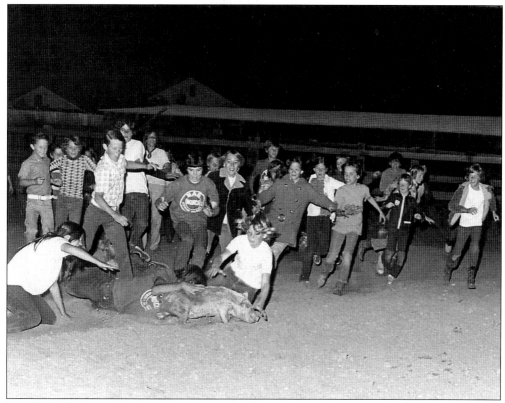

Members of the Norco Activity Boosters hosted this 1960s greased pig contest. The youths learned that it required more than being fast to catch and hold onto one excited little greased pig that didn't want to be caught. This Fourth of July event is always fun for the participants and the onlookers, who enjoy a good laugh. The contest usually goes on until the pig catchers either catch the pig or just run out of energy.

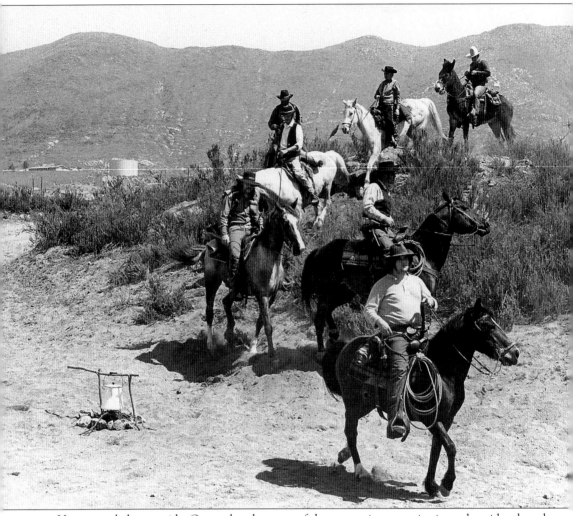

Horse people love to ride. On weekends, many of the equestrian organizations plan rides though the local hills or to overnight campsites. There is an ongoing effort to have local residents help maintain the more than 95 miles of trails located in the city.

The names of these best pals and their owners are unknown, but this is typical for Norco, where domestic and farm animals are raised together and grow up as trusting friends.

Each year since 1970, the City of Norco and its residents and merchants set aside a week to celebrate the horse. The International Professional Rodeo Association holds championship rodeo events on several evenings during "Horseweek." An unidentified rider tries bull riding.

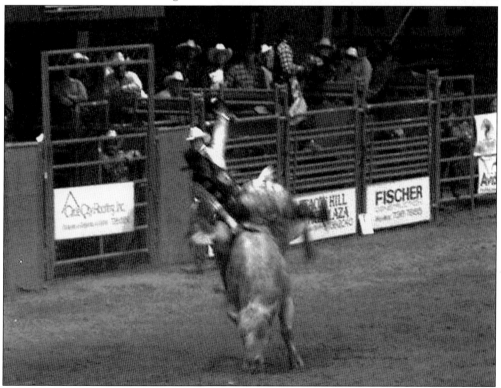

Members of the Norco Mounted Posse in January 2005 include: posse captain Josie Wright, board members Ed Pratt, Chuck Cleave, Ira Stein, Mark McNeil, John Gunther, and Lewis Barlow, Roy Beaver, Max Gohr, Doug Gorman, Mary Gunther, Alan Leggett, Mary McNeil, Bill Montgomery, Matt Nolan, Becky Pacek, Corinne Powell, Don Schulz, Cliff Shappee, Denise Sones, Jim Underwood, Randy Vanderbarke, Doug Wozny, and Bob Wright. (Courtesy of R. W. Laurence.)

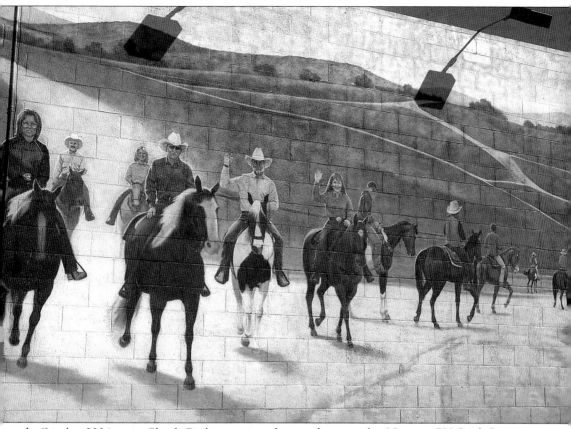

In October 2004, artist Chuck Caplinger painted an outdoor mural in Norco at 790 Sixth Street on the side of the Circle K. The 39-by-16-foot mural captures the essence and spirit of the horse-loving city. Mayor Frank Hall drew names from a hat to select the six men and four women who would represent the local horse community. This was the first time that the artist depicted living people in his work.

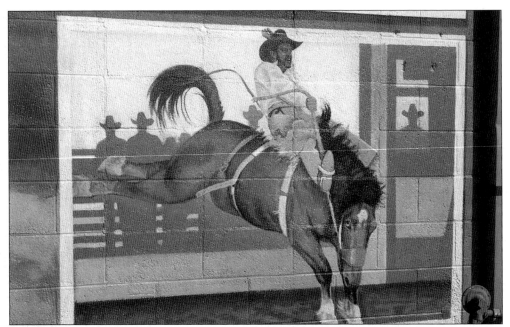

The mural by Caplinger has three panels on the right side and this one honors the brave riders who experience the thrill of riding bareback on broncos. The artist has captured the spirit of the West as the cowboy positions his heels over the horse's shoulders as he starts out of the chute.

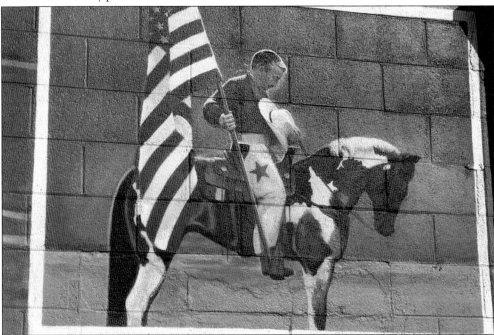

Rodeos are filled with tradition. In this scene, artist Chuck Caplinger shows a single rider paying respect to America and the U.S. flag. The mural was sponsored by several of the local organizations including Hoof Beats of Norco, Saddle Sore Riders, The Cowgirls Way Equestrian Drill Team, Norco Horsemen's Association, Renegade Riders, Norco Mounted Posse, and the R.U.R.A.L. civic organizations.

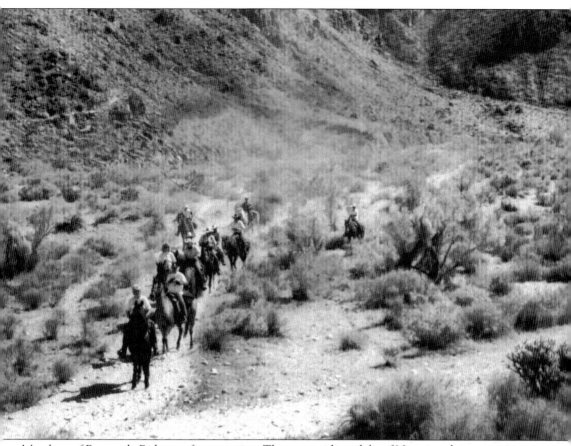

Members of Renegade Riders go for an outing. The many riding clubs of Norco work to preserve the rural atmosphere of the city. Riding clubs often hold fund-raising events that provide proceeds for scholarships and trail improvements in the city. Safety is always a priority and rides are action-packed fun.

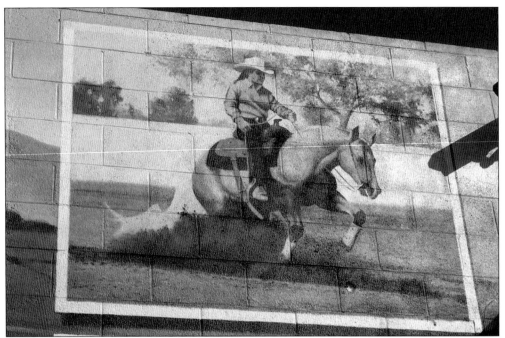

In this scene, artist Chuck Caplinger depicts a cowgirl riding her horse into an arena, honoring the bold women horseback riders of Norco. Caplinger's studio is in the high desert community of Twenty-nine Palms, California. His work is exhibited in Texas and in the high desert area.

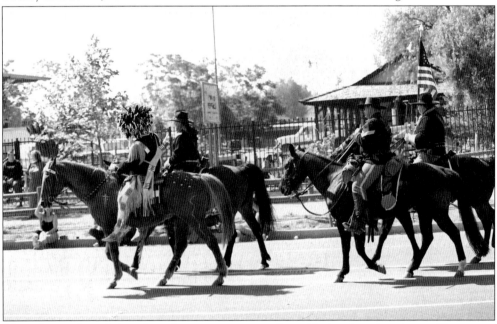

The calvary rides side by side with someone costumed as a Native American brave. The events of Horseweek celebrate the history of the Wild West with authentic costumes, decorations, decorative saddles, and the spirit of the cowboy. A small but hard-working volunteer committee started Horseweek for the enjoyment of the citizen of Norco. The yearly event provides affordable fun for the entire family.

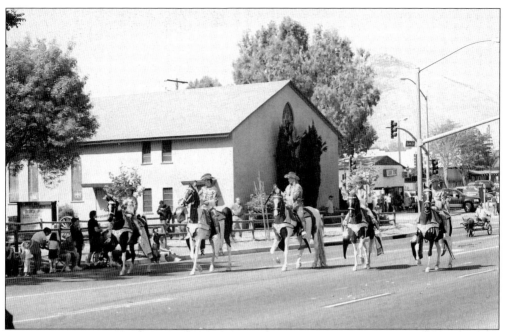

A big treat for young and old during Horseweek is watching the horses and riders in the annual parade that launches the week of popular community events. Horses are groomed with ribbons and bows for this fun parade, and riders traditionally toss candy to the youngsters who eagerly watch from the sidelines.

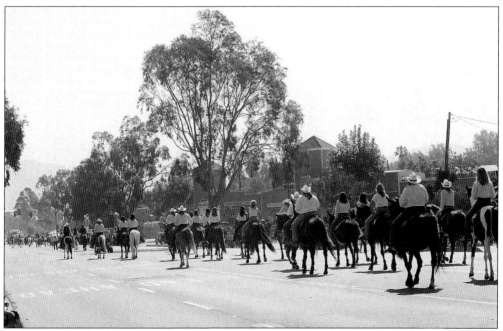

The Horseweek parade goes a short distance down Sixth Street toward Ingalls Park and provides a great opportunity for local residents to get outdoors and spend time with family and friends. Norco has at least 14 horse organizations, and members of these local groups enjoy the ride together, dressed to represent their organization.

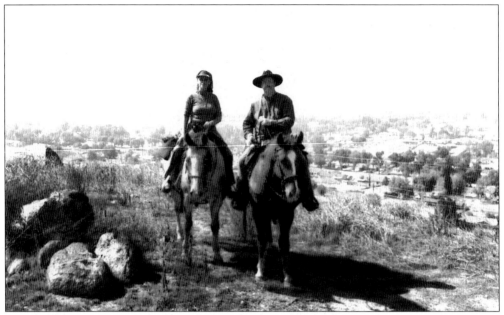

A pleasant afternoon ride in the hills provides relaxation and exercise. Two riders enjoy the beautiful Norco valley from high above a hilltop. Norco was designed with many trails so that horse lovers can get away from town and enjoy a good ride with a scenic view and still be only minutes from home.

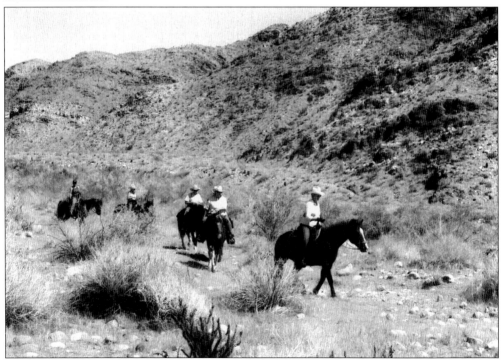

The City of Norco has produced a convenient guide with recommended trail rides designed to acquaint riders with many of the city's historic sites. One of the suggested rides visits the oldest school, church, and home in Norco.

Even cowboys need to take a break. A mule waits for its owner at a rest spot.

These unidentified people are participating in calf roping at a Norco rodeo. Calf roping is an authentic ranch skill practiced by working cowboys and is used for branding calves. In calf roping, calves are given a head start before the rider overtakes and ropes the calf, gets off the horse, captures the calf, and ties three of its legs together with a six-foot rope.

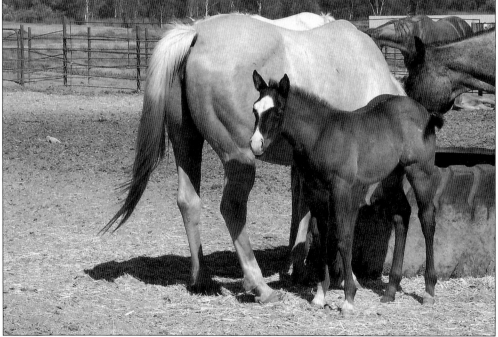

People have been attracted to horses since the dawn of civilization. Responsible horse owners need to have the time to care, groom, feed, and respect their horses. Throughout history, horses have been used for plowing fields, transportation, and for sport. October 2005 has been designated as the International Month of the Horse.

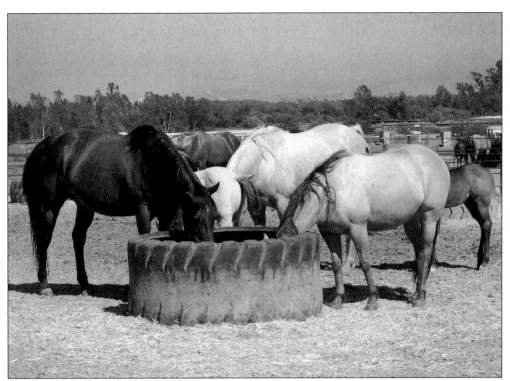

Horses eat about 25 pound of feed or hay a day. Since a typical horse weighs about 1,000 pounds, they need to eat about two pounds of food for every 100 pounds of body weight. In the winter months, horses that live outdoors need more food to keep warm. The amount of food a horse needs depends on such things as size, breed, age, and activity. Horses also need plenty of fresh water. A typical full-grown horse drinks about 5–10 gallons of water a day.

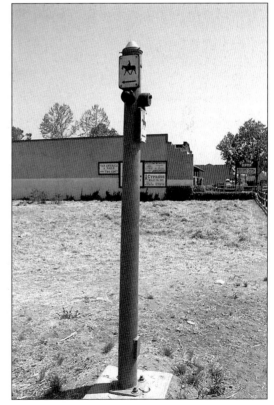

People out for a walk who want to cross the street can push pedestrian push buttons at the street corner, but for people on horseback the button is too low to reach. The City of Norco has added equestrian push buttons along popular horse trails, which are mounted higher so that riders can reach them without dismounting.

The following song, entitled "Last Rodeo," was written by poet-singer-songwriter Ben Rombouts, a longtime Norco resident:

There's a full moon that silhouettes the mountains,
Casting shadows on Rattle Snake Hill;
A thousand miles he has traveled with a few more left to go,
He's headed to that place that he calls home.

From Amarillo to Reno, Nevada,
And all the whistle-stops in between,
He won a few but life had more than evened up the score
So on this part of life he'll close the door.

Broken bones, broken dreams, tired heartache,
There's so much that will no longer mend;
He turns his rig to the home that he left so long ago,
This is his last rodeo.

Ten
People and Places

This beautiful young woman is dressed in the stylish fashion of the early 1900s. A fruit orchard lines the road on the left. The unidentified woman is probably standing in the middle of what later became known as Hamner Avenue. There is a noticeable absence of telephone lines and poles in this photograph.

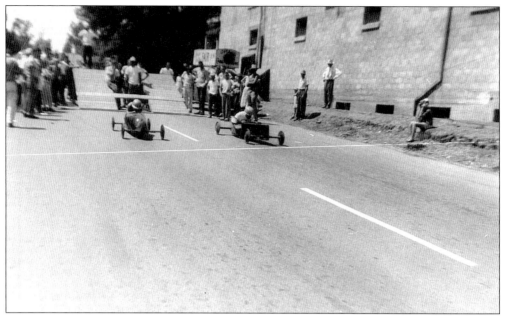

Racing became popular in the 1950s especially in Southern California. The soapbox derby cars had no engines and required no fuel. Here two unidentified soapbox derby racers start a race while old and young spectators eagerly watch the competition on the sidelines.

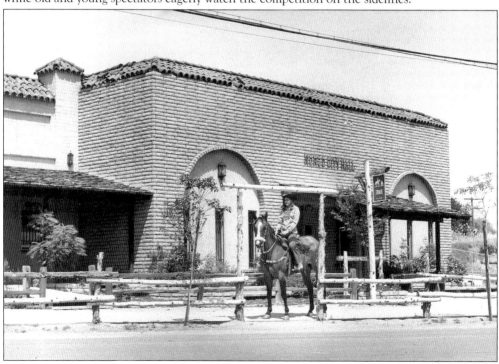

A lone rider passes Norco's original city hall sometime in the 1960s. Norco was incorporated in December 1964, after residents spent more than a year researching the feasibility of incorporation. There was much concern about maintaining both Norco's rural environment and the large lots that were suitable for animal keeping.

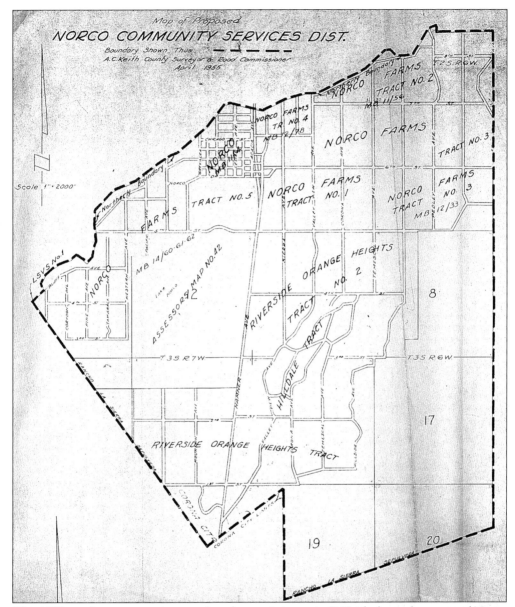

This 1955 map by county surveyor and road commissioner A. C. Keith shows the proposed Norco Community Services District before the city's incorporation. Indicated on the map are boundaries of the future city as well as various farm and housing tracks division lines.

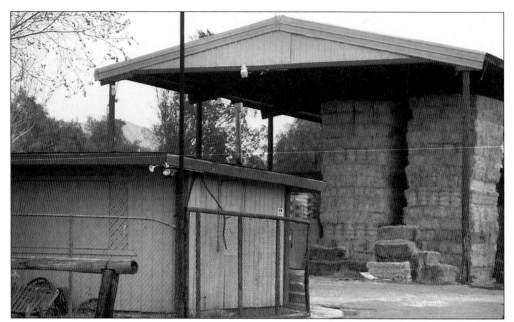

Norco is a rural community whose over 20,000 horses require feed. Here hay stacked in a barn is ready for customers. This feed store is typical of the many feed and grain stores that operate in Norco. Tack shops and stores selling products and gear for horses and their riders are also abundant.

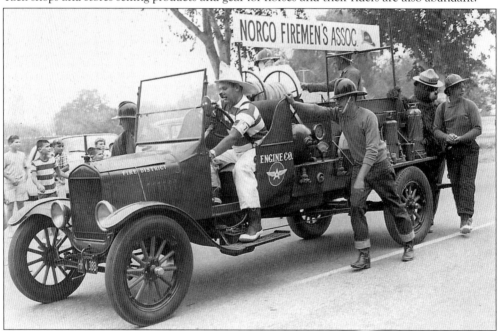

The Norco Volunteer Fire Department was established in 1957. One of its prized possessions is this restored fire engine that is always popular in the city's many parades. The fire department has up-to-date equipment and professional firefighters; some of these brave people were on active duty in New York following the September 11 World Trade Center disaster. The fire department is responsible for fire, rescue, emergency medical and paramedic services, hazardous materials response and public fire safety, education, and disaster preparedness services.

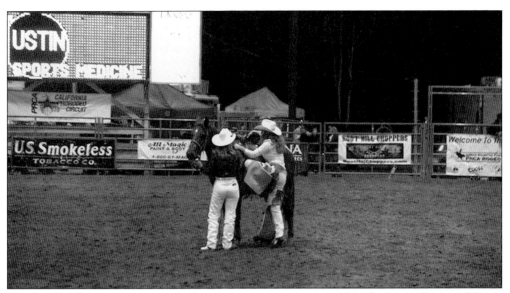

Two lovely ladies are busy in the rodeo ring as one prepares to ride. The Norco Mounted Posse hosts two rodeos each year, one in January and one in August. The Professional Rodeo Cowboy Association is the largest and oldest rodeo organization in the world. It is believed that rodeos began as a sport in the late 1860s; however the organization did not formally come into existence until 1975. (Courtesy of R. W. Laurence.)

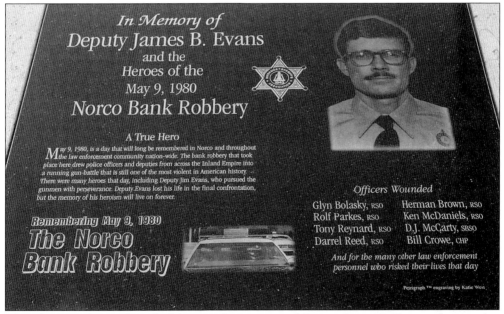

This plaque in front of city hall honors the memory of Deputy James B. Evans, who gave his life in the line of duty, as well as other brave men who were wounded. On May 9, 1980, five armed men attempted to rob a bank on Fourth and Hamner Streets of $20,000. A long chase took place through the streets, and gunfire resulted in the death of Deputy Evans. Officers who were wounded included Riverside Sheriff Officers Glyn Bolasky, Rolf Parkes, Darrel Reed, Tony Reynard, Herman Brown, and Ken McDaniels, and San Bernardino Sheriff Officer D. J. McCarty, as well as California highway patrolman Bill Crowe.

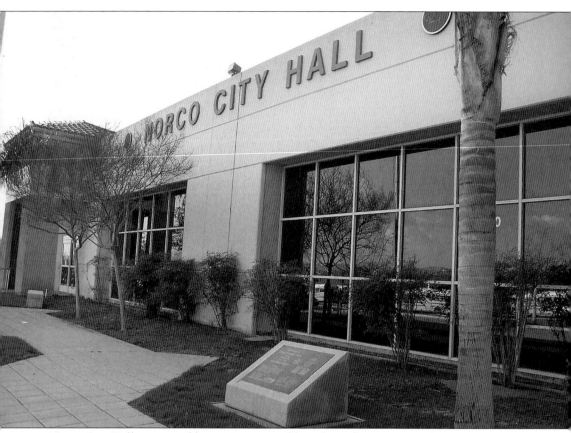

Norco City Hall is pictured here. Norco is and has always been an animal-keeping, equestrian-oriented community in western Riverside County. Recent demographics show that the annual median income for residents is over $74,000, which economically places it in the top 10 cities of the Inland Empire. The city employs over 100 people who work for the Norco City Fire, Parks, Recreation, Community Services, Community Development, Economic Development, Administrative Services, and Public Works Departments.

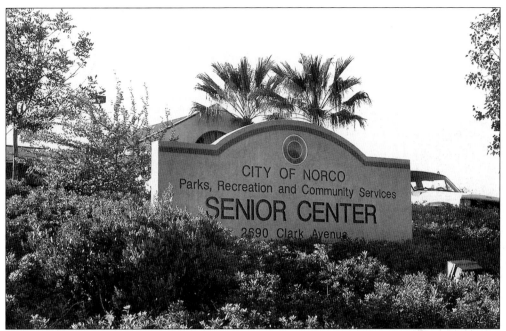

The Norco Senior Center offers a "hands-on" recreation center for seniors complete with a relaxing 1.4-acre garden. Seniors are able to participate in a community garden and orchard program, which allows them to grow, and harvest the results of their labor. The 8,000-square-foot facility, located at 2690 Clark Street, also provides senior nutrition programs, senior town hall meetings, and a wide variety of day trips.

This business park off of Hamner Avenue has room for multiple tenants and is a newer addition to the economic growth of the city. The Norco Network Business Center includes 21 units totaling 35,341 square feet and eight industrial park buildings. Other new centers include the Norco Trails Business Park on Second Street.

The hills on the east side on Norco have ample undeveloped acreage. Proud of these wide open spaces, the city has created an Adopt a Trail Program, which promotes positive civic responsibility so that individuals, businesses, and organizations will have a stake in maintaining the rural beauty of the city. The program provides for each person or organization to keep a specified trail weed and trash free for one year.

In 1993, the Norco Public Library moved into the former Norco City Hall on Old Hamner. This move allowed additional space for a bookstore for the Friends of the Library, and space for the Norco Historic Society. The library has an entire room dedicated to equine reference information.

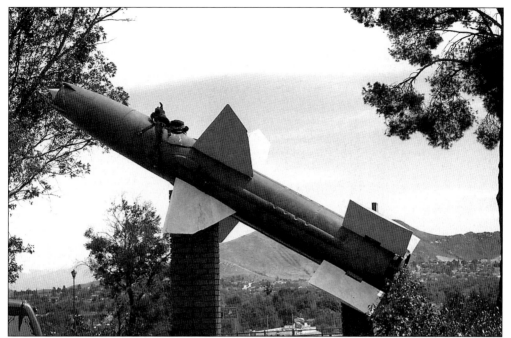

The Norco American Legion Post No. 328 was established in 1929 and is located at the corner of Hamner Avenue and Veterans Memorial Street. Outside the post is this Talos missile with a leather saddle. The Talos was a long-range surface-to-air missile that had a range of 65 nautical miles. Talos missiles were used during the Vietnam War. Most were phased out by 1979.

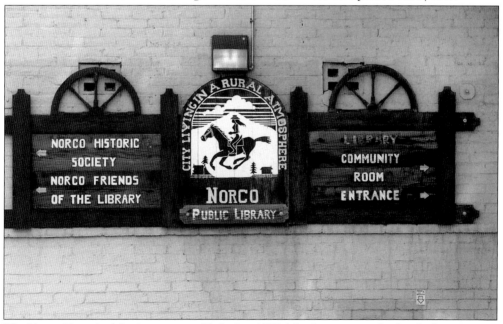

The Norco Historical Society was established in 1987. Members are involved with documenting the historic artifacts of the city and ensuring that the historic items are available to the public at selected times. They also maintain a mini-museum that holds historic artifacts and memorabilia from the early days of the city.

Renovated in 2004, Nellie Weaver Hall is the site of city fairs, dances, and a variety of other events. A 10,000-square-foot facility with a full industrial kitchen and auditorium seating for 500, it is ideal for weddings, reunions, and large parties. It is named in honor of Norco former mayor Nellie Weaver.

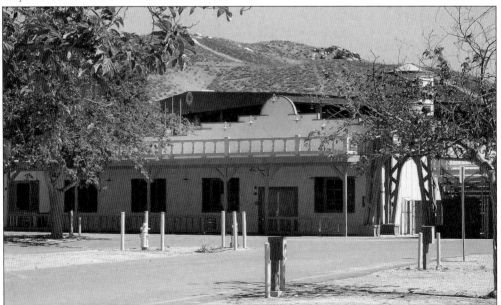

Adjacent to Nellie Weaver Hall is Ingalls Park, an outdoor amphitheater that has seating for up to 1,300. The facility has wonderful acoustics and is a great outdoor location for a variety of events, including Norco's rodeos and the annual Norco Valley Fair. Ingalls Park was named in memory of George Alan Ingalls, a Norco hero who died in the Vietnam War.

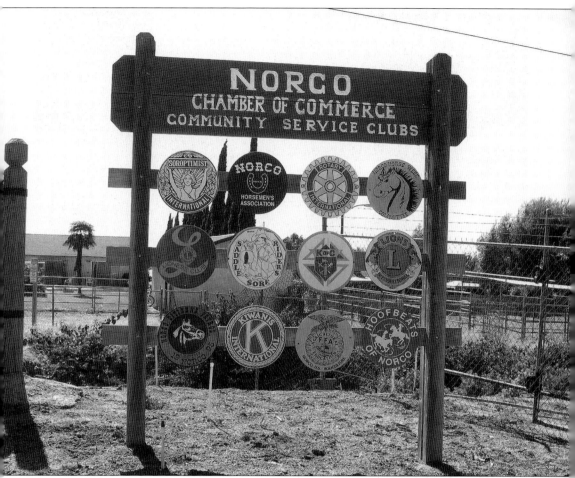

Norco has a variety of civic organizations that include over a dozen related to the horse. The following organizations are represented on this sign that stands at the eastern border to the city: Soroptimist International, Norco Horsemen's Association, Rotary International, Norco Horseweek Committee, Lioness Club, Saddle Sore Riders, Knights of Colombus, Lions Club International, Norco Citizen Patrol, Kiwanis International, FFA Agricultural Education, and the Hoofbeats of Norco.

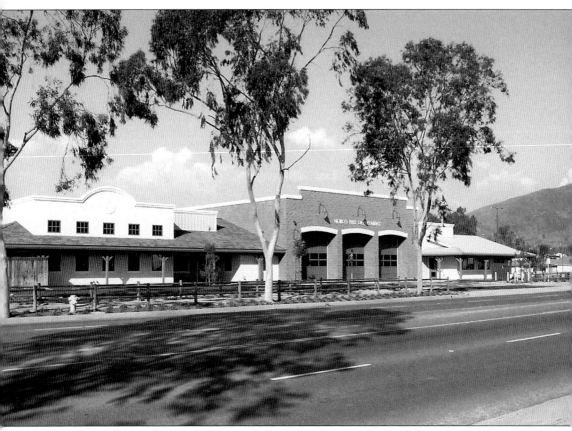

Norco's new fire station on Sixth Street reflects the Western theme of the city. The city council approved the construction of the new buildings in 2004, and the completed station is already a landmark—as the red brick building with its bright red doors stands out from the rest of the businesses and complements the landscape.

Nellie Weaver was a popular member of the community. She served two terms as mayor, from 1973 to 1974 and from 1976 to 1977. Many longtime residents describe Nellie as a great lady who made many contributions to the city. (Courtesy of City of Norco.)

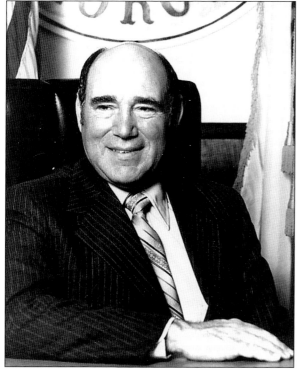

Steve Nathan was mayor of Norco from 1981 to 1982 and from 1983 to 1984, and served on the city council for a total of 12 years. While he was on city council, the Norco campus of Riverside Community College opened. (Courtesy of City of Norco.)

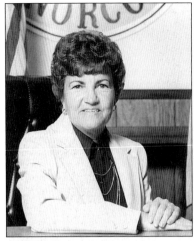

Naomi R. Feagan was mayor of Norco from 1980 to 1981 and from 1984 to 1985. (Courtesy of City of Norco.)

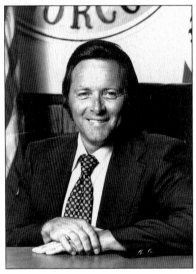

Ron E. Wildfong was mayor of Norco from 1982 to 1983 and from 1986 to 1987. (Courtesy of City of Norco.)

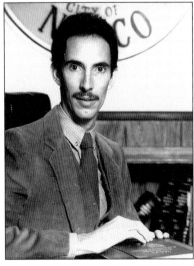

John W. Casper was Norco's mayor from 1987 to 1988. Courtesy of City of Norco.)

John Cobbe was mayor of Norco in 1990. (Courtesy of City of Norco.)

Richard L. MacGregor served three terms as mayor: from 1985 to 1986, from 1988 to 1989, and from 1990 to 1991. (Courtesy of City of Norco.)

From 1992 to 1993, local business owner Larry B. Cusimano was mayor of Norco. (Courtesy of City of Norco.)

Terry A. Wright was mayor of Norco from 1994 to 1995. He was also active on the Norco Planning Commission and the Streets and Trails Commission. (Courtesy of City of Norco.)

William "Bill" Vaughan served two terms as mayor from 1993 to 1994 and from 1995 to 1996. (Courtesy of City of Norco.)

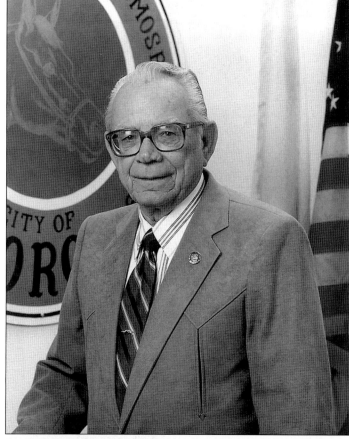

As a tribute to former mayor Bill Vaughan, who passed away in 1997, this granite plaque was installed outside of city hall. It honors a man who donated much of his time to the City of Norco. (Courtesy of City of Norco.)

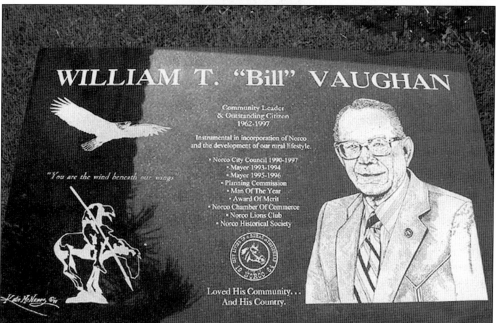

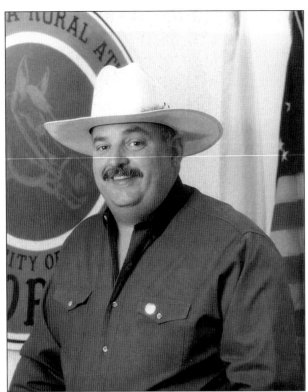

Robbin G. Koziel served as mayor from 1996 to 1997. (Courtesy of City of Norco.)

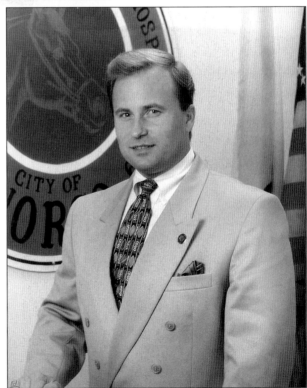

Christopher L. Sorensen was mayor of Norco from 1997 to 1998. (Courtesy of City of Norco.)

Barbara Carmichael was mayor of Norco from 1991 to 1992 and from 1998 to 1999 and served as mayor pro tem three times. She accomplished much for the residents through her service on Norco City Council. (Courtesy of City of Norco.)

Longtime resident Herb Higgins is the 2005 mayor of Norco and is a longtime member of the Norco Chamber of Commerce. (Courtesy of City of Norco.)

Pictured here are the members of the 2005 Norco City Council. From left to right are (first row) Hal Clark, who was elected in November 1997 and served as mayor in 2000–2001; current mayor Herb Higgins; (second row) Frank Hall, who was elected in November 1997 and served as mayor in 1999, 2000, and 2003–2004; Kathy Azevedo, the current mayor pro tem, elected to city council in 2003; and Harvey Sullivan, who served as mayor in 2003 and is currently a council member. All member of the city council are longtime residents of Norco.

BIBLIOGRAPHY

"The Ranch House at the Warner's." *The Journal of San Diego History* 42. Fall (1996).

60 Years, A Tribute to 60 Years of Service to the Navy. Corona Division: Naval Surface Warfare Center, 2002.

Brady, Nancy W. "Early California History: Exploration and Settlement Curriculum Guide." The Bowers Museum of Cultural Art. Santa Ana, California. Harcourt, Brace Publishers Mar 1999.

Cobbe, Sue, Ron Snow, and Linda Bruinsma. *Norco Remembers.* Norco, California. 1989.

Davis, William H., and Andrew S. Leary. *Sixty Years in California.* San Francisco: John Howell Publishing, 1889.

Freed, Gloria S. *The History of Corona: The Circle City.* Encinitas, California: Heritage Media Corporation, 1998.

Kubiak, Leonard. *History of the Stage Coach in the West.* http://www.forttumbleweed.com

Morse, Janice. "Council pay hasn't changed since 1928." *The Cincinnati Enquirer.* Cincinnati: Gannett Co., Inc.

Reynolds, Stanley, and Fred Eldridge. *Corona California Commentaries.* Los Angeles: Sinclair Printing, 1986.

Watson, Douglas S., ed. *Missons and Their Wealth: Hacendados and Their Property.* San Francisco: John Howell Publishing, 1929.